Remembering

Baton Rouge

Mark E. Martin

TRADE PAPER
PRESS

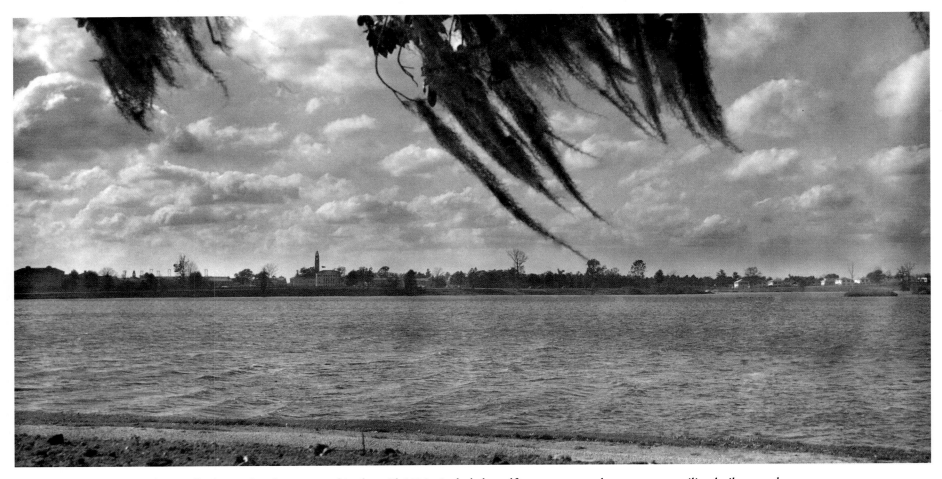

The Baton Rouge City Park, initially designed and constructed in the mid-1920s, included a golf course, zoo, and amusement pavilion built around a small lake created by digging out swampy lowlands. During the Great Depression, the Works Progress Administration spearheaded a project to expand the original lake and construct more lakes south toward Bayou Duplantier and the Louisiana State University campus. This image from around 1935 provides a view across the lake toward the university.

Remembering

Baton Rouge

Turner Publishing Company
200 4th Avenue North • Suite 950
Nashville, Tennessee 37219
(615) 255-2665

Remembering Baton Rouge

www.turnerpublishing.com

Library of Congress Control Number: 2010926217

ISBN: 978-1-59652-694-5

Printed in the United States of America

10 11 12 13 14 15 16—0 9 8 7 6 5 4 3 2 1

CONTENTS

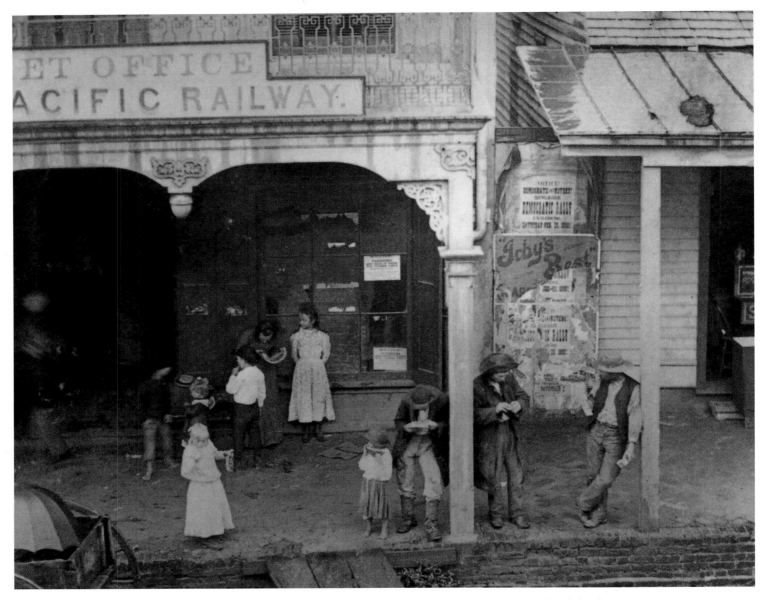

Citizens enjoy watermelon in the shade of the Texas & Pacific Railway office gallery on Main Street. Behind the three men, a poster announces a February 20, 1892, Democratic Party rally.

Acknowledgments

This volume, *Remembering Baton Rouge,* is the result of the cooperation and efforts of many individuals and organizations. It is with great thanks that we acknowledge the valuable contribution of the following for their generous support:

Library of Congress
Louisiana State University—Special Collections
State Library of Louisiana

My undying thanks to L. A. B. for her insightful comments and editorial advice.

—*Mark E. Martin*

PREFACE

Baton Rouge has thousands of historic photographs that reside in archives, both locally and nationally. This book began with the observation that, while those photographs are of great interest to many, they are not easily accessible. During a time when Baton Rouge is looking ahead and evaluating its future course, many people are asking, How do we treat the past? These decisions affect every aspect of the city—architecture, public spaces, commerce, infrastructure—and these, in turn, affect the way that people live their lives. This book seeks to provide easy access to a valuable, objective look into the history of Baton Rouge.

The power of photographs is that they are less subjective than words in their treatment of history. Although the photographer can make subjective decisions regarding subject matter and how to capture and present it, photographs seldom interpret the past to the extent textual histories can. For this reason, photography is uniquely positioned to offer an original, untainted look at the past, allowing the viewer to learn for himself what the world was like a century or more ago.

This project represents countless hours of review and research. The researchers and writer have reviewed thousands of photographs in numerous archives. We greatly appreciate the generous assistance of the individual and organizations listed in the acknowledgments of this work, without whom this project could not have been completed.

The goal in publishing this work is to provide broader access to this set of extraordinary photographs that seek to inspire, provide perspective, and evoke insight that might assist people who are responsible for determining Baton Rouge's future. In addition, the book seeks to preserve the past with adequate respect and reverence.

With the exception of touching up imperfections that have accrued with the passage of time and cropping where necessary, no changes have been made. The focus and clarity of many images is limited by the technology and the ability of the photographer at the time they were taken.

The work is divided into eras. Beginning with some of the earliest known photographs of Baton Rouge, the first section records photographs

through the end of the nineteenth century. The second section spans the beginning of the twentieth century through World War I. The following sections then move decade by decade from the 1920s through the 1940s, and the concluding section covers the postwar era into the 1960s.

In each of these sections we have made an effort to capture various aspects of life through our selection of photographs. People, commerce, transportation, infrastructure, religious institutions, and educational institutions have been included to provide a broad perspective.

We encourage readers to reflect as they go walking in Baton Rouge, strolling through the city, its parks, and its neighborhoods. It is the publisher's hope that in utilizing this work, longtime residents will learn something new and that new residents will gain a perspective on where Baton Rouge has been, so that each can contribute to its future.

—Todd Bottorff, Publisher

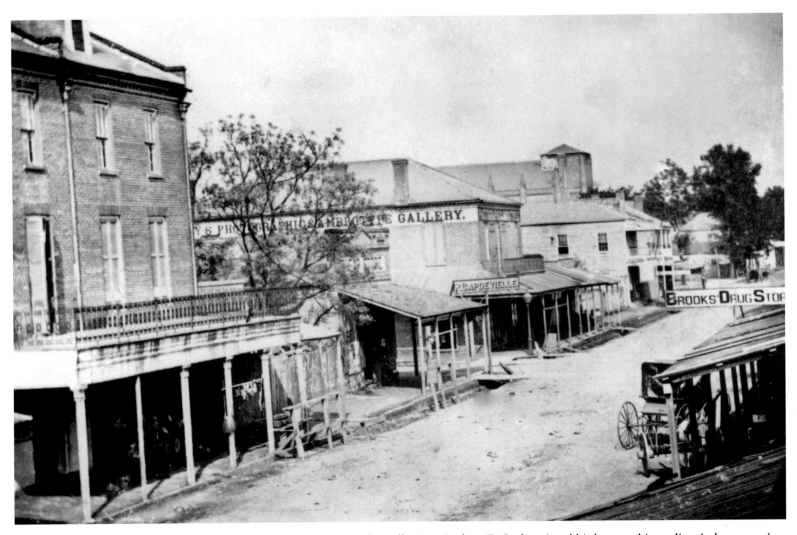

The photographer of numerous images in this collection, Andrew D. Lytle pointed his lens out his studio window sometime around 1866 and captured this view looking up Main Street away from the Mississippi River. Businesses visible include the Brooks Drug Store at 210 Main and Marion P. McCarthy's Photographic and Ambrotype Gallery at 314 Main. The blunt tower seen in the distance was part of Saint Joseph Catholic Church at 403 Main. Lytle's studio stood at 208 Main.

Nineteenth-Century Baton Rouge

(1850s–1899)

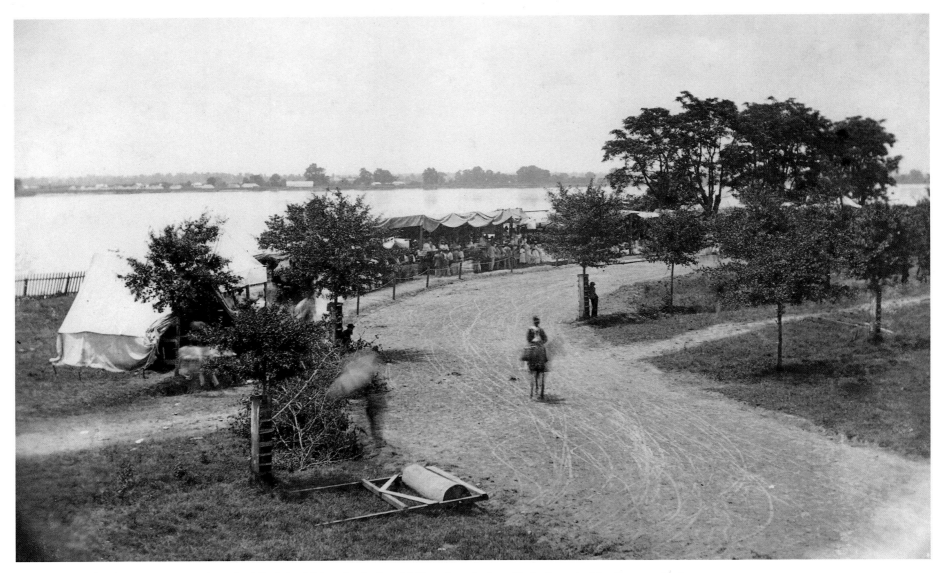

The western side of Baton Rouge ends at the Mississippi River. In the late 1850s, when Andrew D. Lytle took this photograph of a riverside social event, the townspeople attending would have ridden or walked dirt streets to the river's edge, in this case at the intersection of North and Lafayette streets.

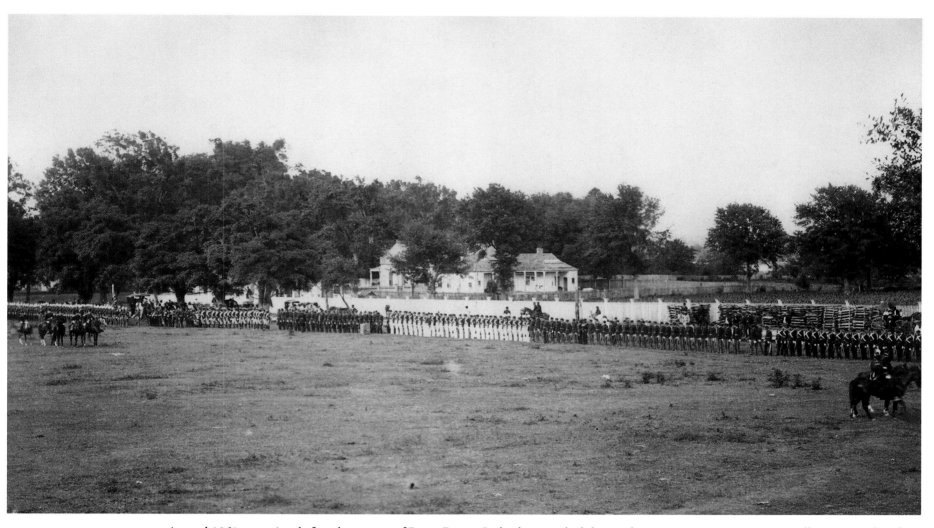

Around 1861, sometime before the capture of Baton Rouge, Lytle photographed these militia groups meeting in town. Artillery pieces taken from the Federal Arsenal provided them with weapons, powder, and ammunition. Among the groups here is the Washington Artillery of New Orleans, established in 1838 and still active as the First Battalion, 141st Field Artillery.

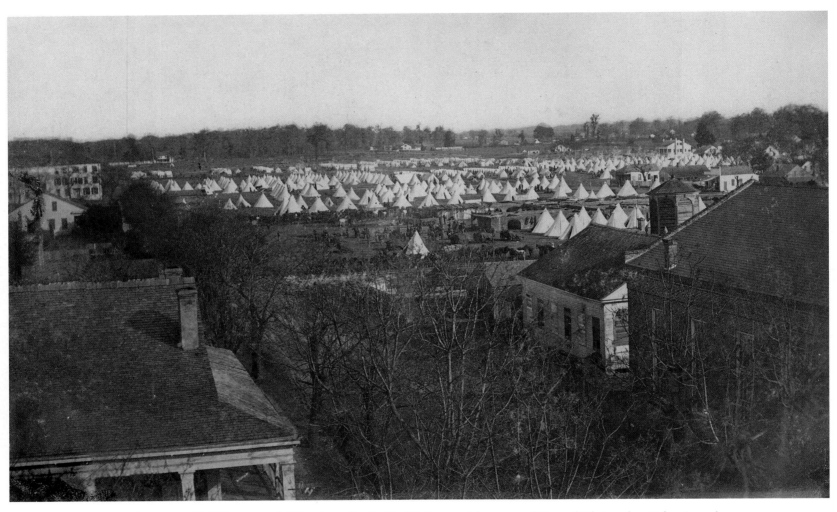

The traveling-photographer team of McPherson and Oliver is credited with this image of the camp of General Christopher Colon Augur's Nineteenth Army Corps, Third Brigade, on the north edge of Baton Rouge around 1863. This area had been a United States Army arsenal and camp before the war. Tens of thousands of Federal troops and sailors lived in Baton Rouge before the fall of Port Hudson—the last Confederate stronghold on the Mississippi—less than 25 miles upriver.

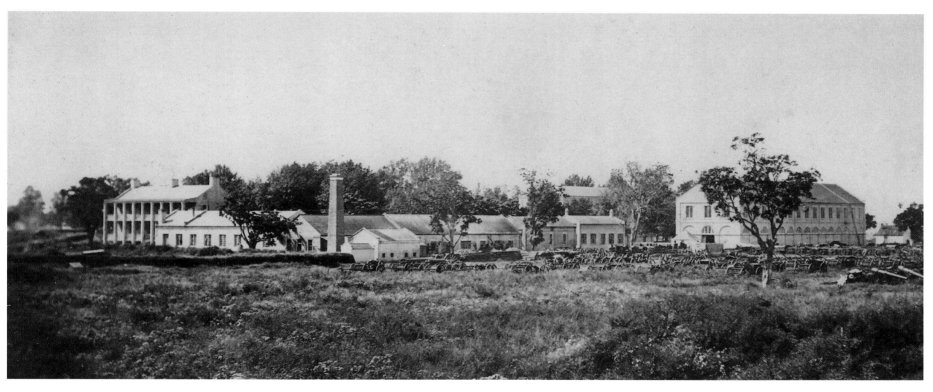

In this image of the Arsenal grounds around 1863, the main Arsenal building stands at right, while one of the Pentagon Barracks buildings can be seen at far left. At the time, Federal troops occupied Baton Rouge.

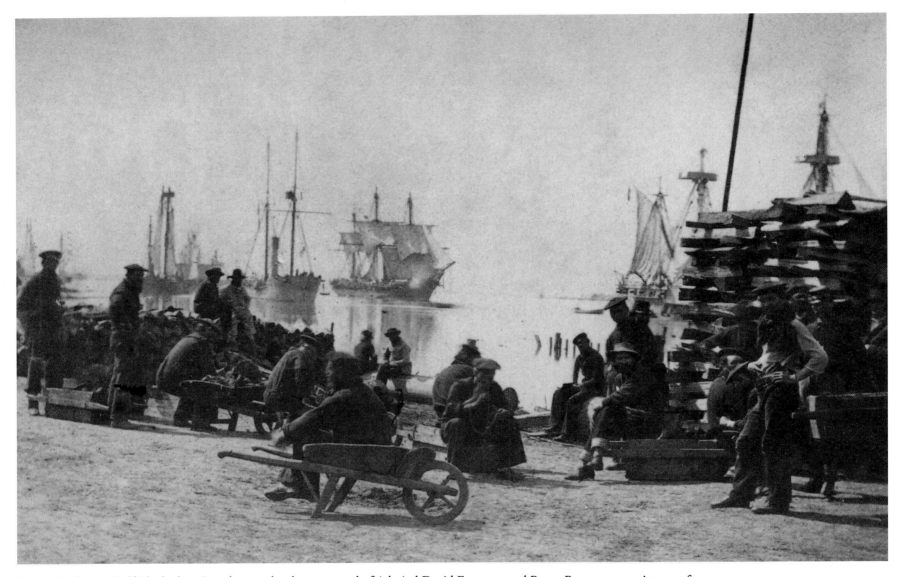

The Federal West Gulf Blockading Squadron under the command of Admiral David Farragut used Baton Rouge as a staging area for many operations on the Mississippi River, especially against Port Hudson. The fleet's coal-and-wood-burning steamers would take on fuel before conducting operations.

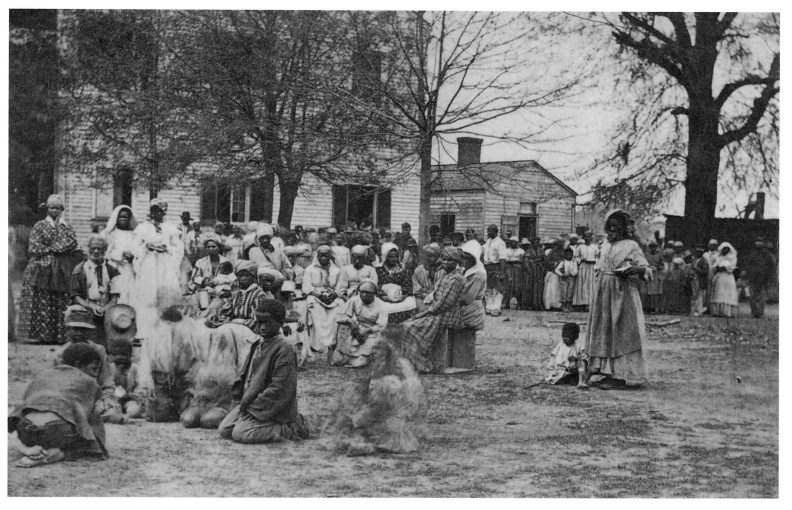

During the occupation of Louisiana, slaves fled captivity into territory controlled by Federal forces. Physically fit men and boys were often drafted into newly established blacks-only Federal military units. Women and children were interned in "contraband camps" like this one in Baton Rouge.

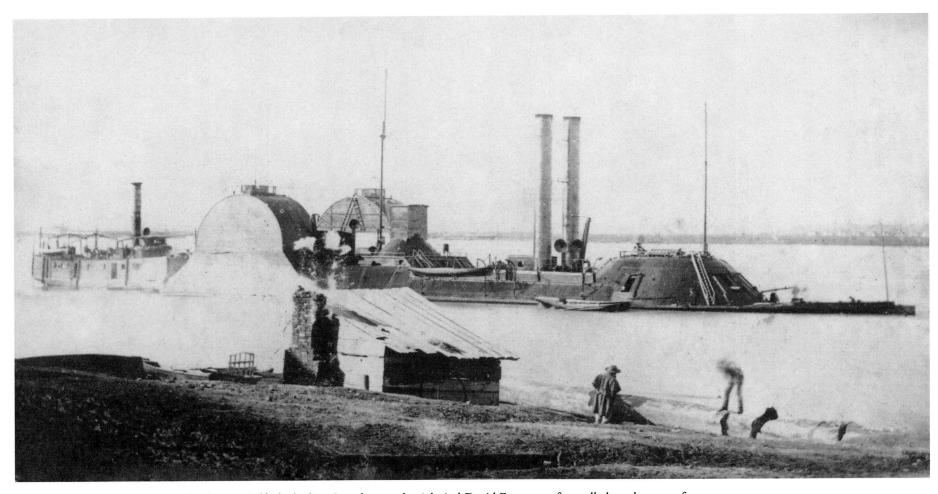

The USS *Choctaw,* part of the Federal West Gulf Blockading Squadron under Admiral David Farragut, often called on the port of Baton Rouge during the war.

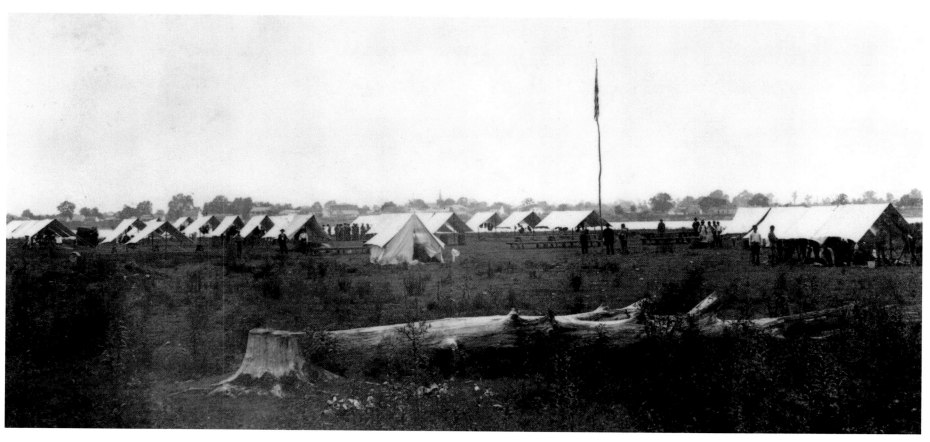

Andrew D. Lytle photographed this Federal Army encampment around 1863.

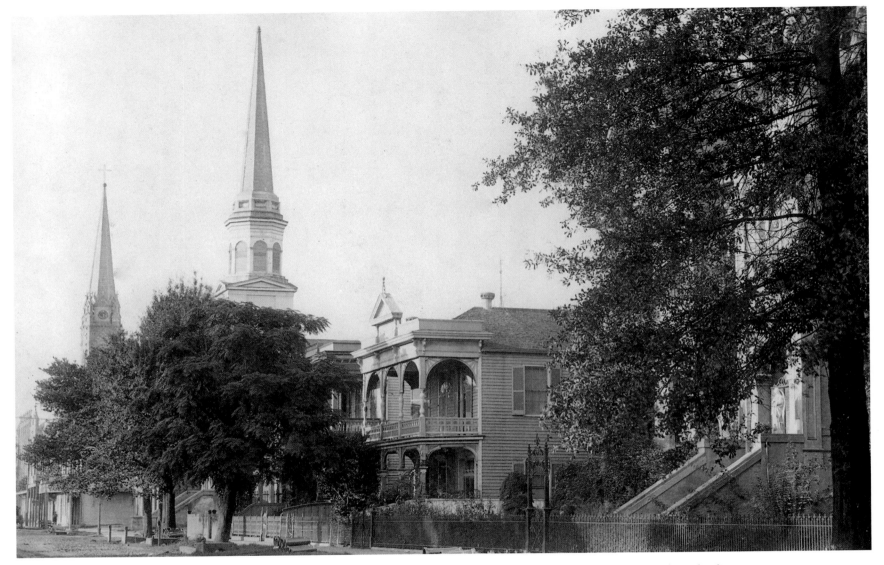

Church Street in Baton Rouge, seen here around 1880, was home to many of the town's houses of faith. In this view, the steeple in the distance belongs to Saint Joseph Catholic Church, now Saint Joseph Cathedral. The nearer steeple graces a church razed in the late 1800s.

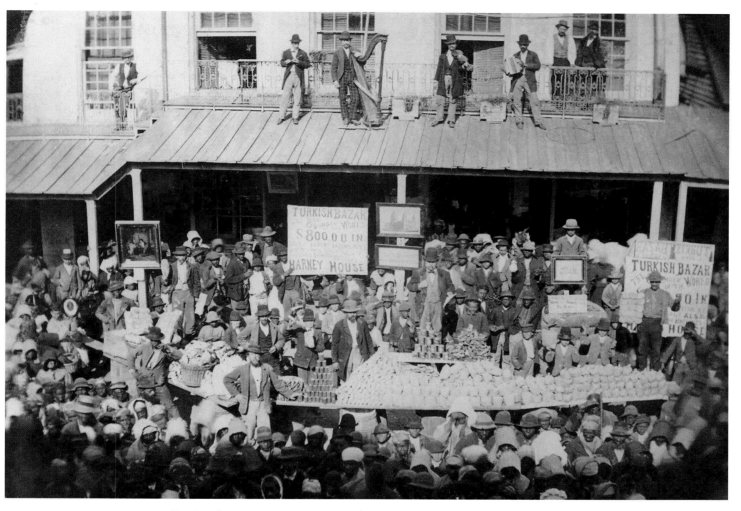

During the 1870s in Baton Rouge, the Harney House put on "Turkish Bazar" events on Main Street, which included, according to the signs, "the eighth wonder of the world." Rooftop musicians with their instruments—a flute, harp, violin, and accordion—survey the crowd here. In 1875, a citizen petition against the bazaars led the mayor to shut down the event permanently.

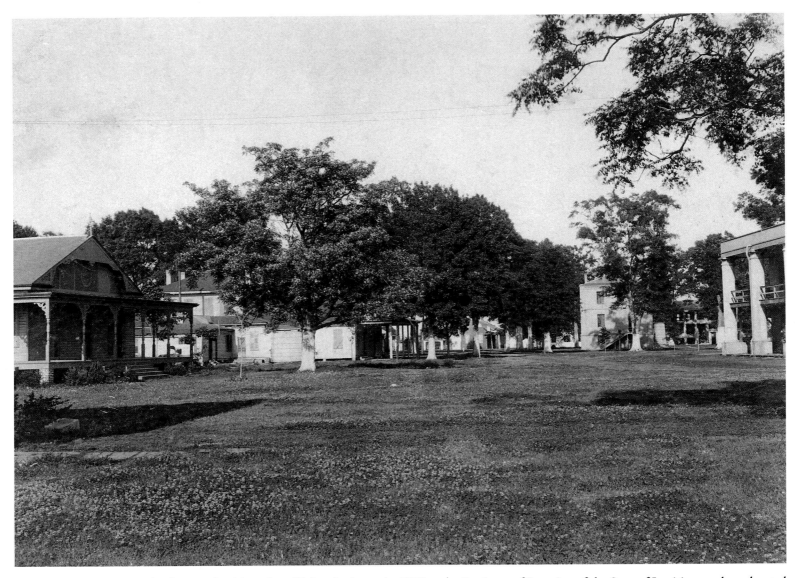

What became Louisiana State University began in 1860 as the Seminary of Learning of the State of Louisiana and was located near Pineville. Following the Civil War, the institution moved a number of times before settling, in 1886, on the old Arsenal grounds on the northern edge of Baton Rouge. This wide-angle view shows the LSU campus interior around 1890. From left to right are the hospital, mess hall, Treasurer's Office, Agricultural Hall, and barracks.

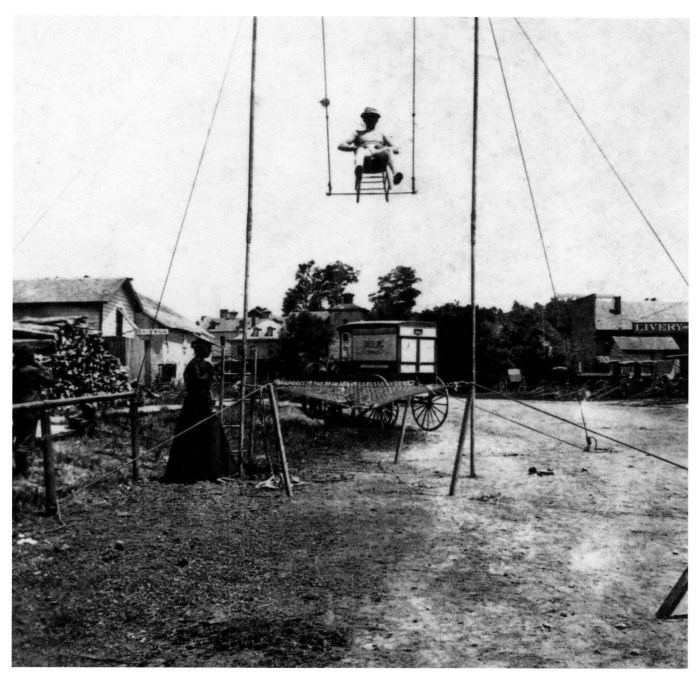

Traveling circuses crisscrossed the country in the late nineteenth and early twentieth centuries. Baton Rouge citizens enjoyed such traveling entertainments as this trapeze act seen about 1899.

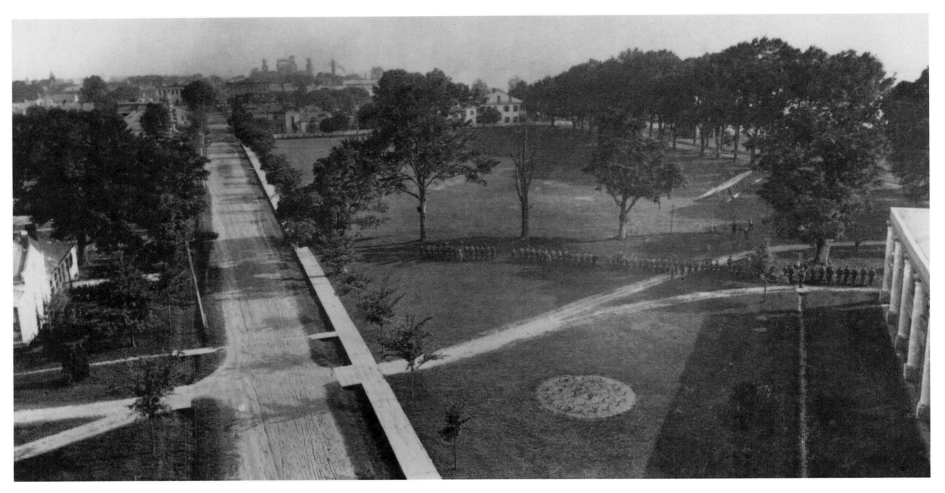

A photographer ran his camera up the flagpole at Third Street on the Louisiana State University campus on the old Arsenal grounds to take this picture of Baton Rouge around 1899. The State Capitol can be seen in the distance, and a part of one of the Pentagon Barracks buildings is visible to the right.

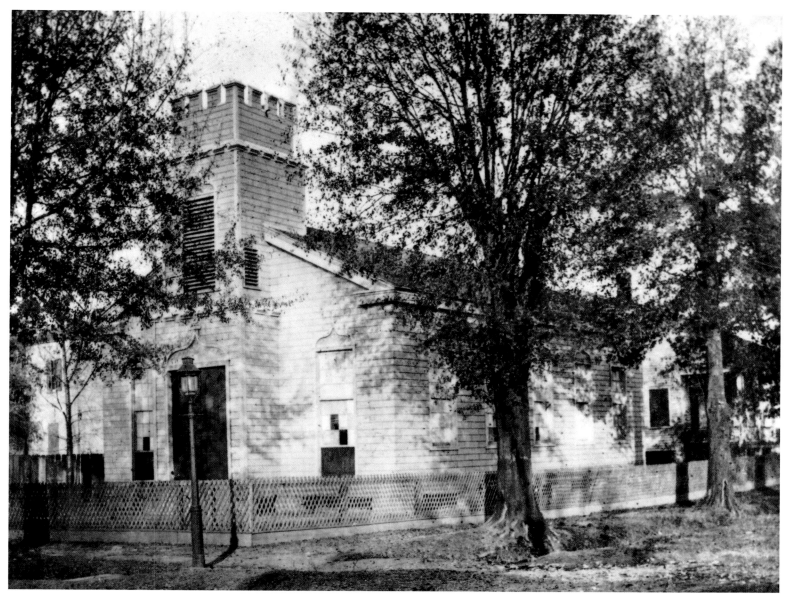

Trees and fencing surround this small church in Baton Rouge around 1890, with a streetlight also visible.

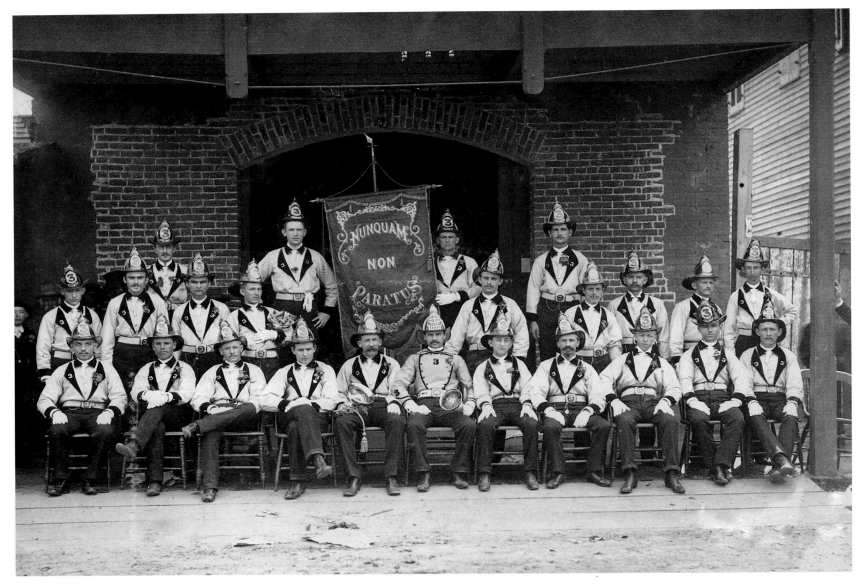

Volunteer fire fighters protected the city before the establishment of the city fire department. Here in 1887, Washington Fire Company No. 3 sits for a group portrait. Their company motto, "Nunquam Non Paratus," translates as "Never Not Prepared." A better translation would be "Always Ready."

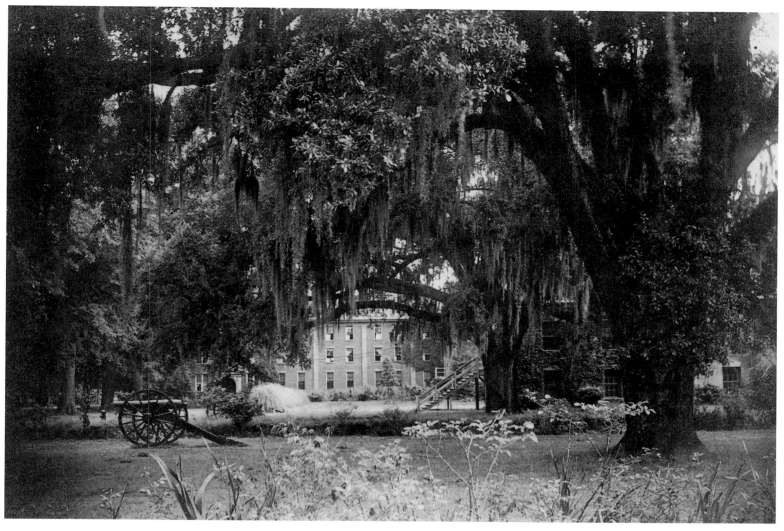

A cannon sits under a moss-draped oak on the campus of Louisiana State University, known as the "Old War Skule." Foster Hall is at center, while bits of Agricultural Hall can be seen on the right behind the trees.

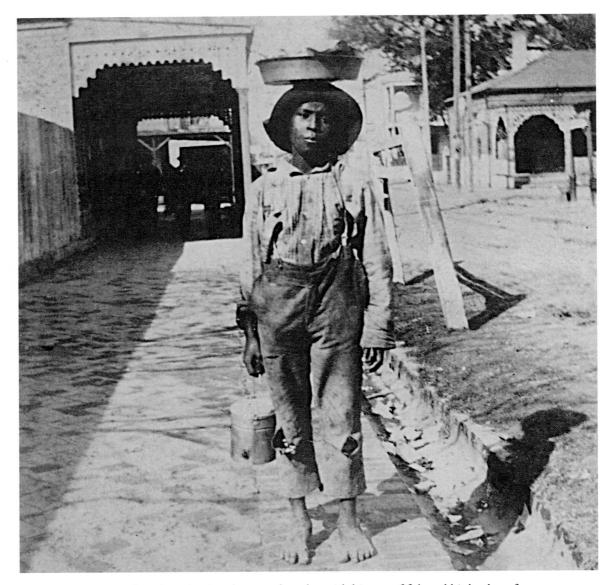

This young man may have been leaving the central market with his pan of fish and his bucket of oil. He stands on the sidewalk near the intersection of Third and Florida streets in downtown Baton Rouge around 1899.

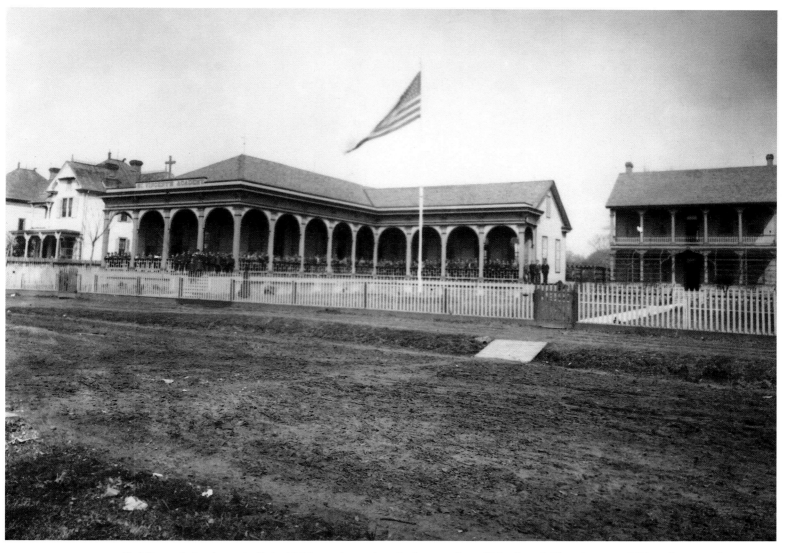

St. Vincent's Academy, built in 1894, was located at the intersection of North and Church streets. Thirty-five years later, a new structure would be built and the name would be changed to Catholic High School for Boys.

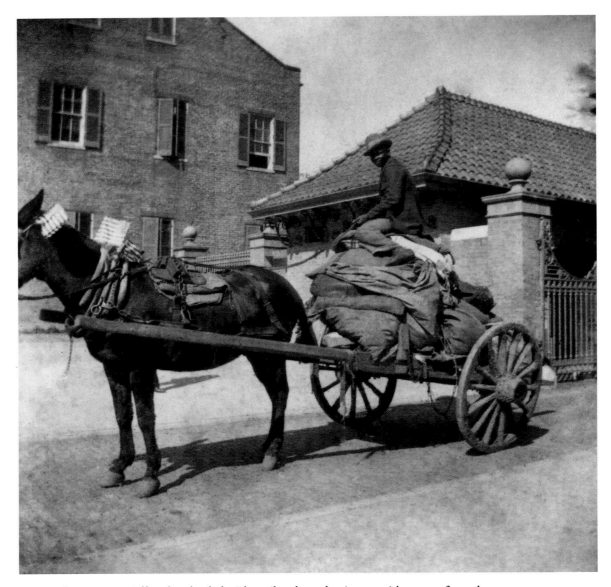

A United States Post Office dray loaded with mail sacks makes its way either to or from the post office on North Boulevard around 1899. The tile-roofed building seen behind the dray served as the post office stables.

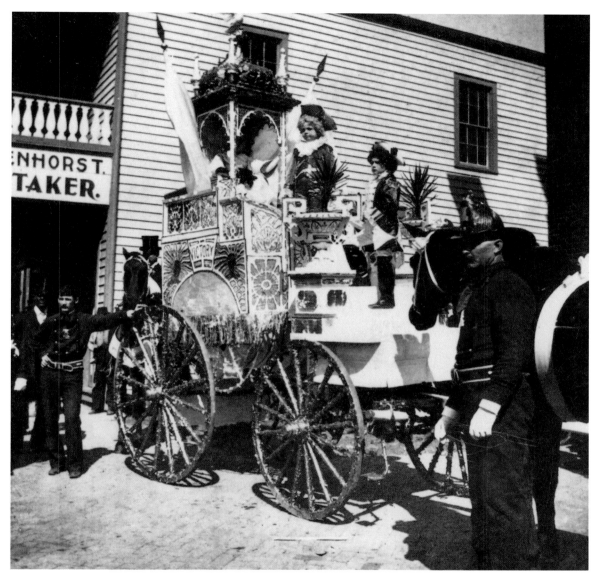

Standing in front of the Washington Fire Company No. 1 firehouse, the float "Victory" prepares for the 1898 Washington's Birthday Firemen's Parade. The sign for Rabenhorst Undertakers, established in 1866, is visible in the background.

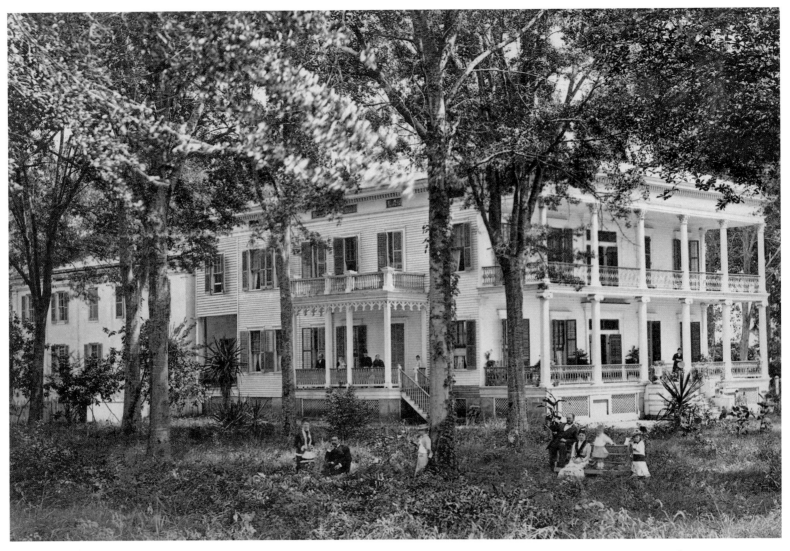

Woodstock Plantation, owned by the Walker family, sat near Bayou Manchac on the southeastern edge of East Baton Rouge Parish. It was one of nearly two dozen plantations in the parish. In this 1889 view, the Walker family poses before the main house.

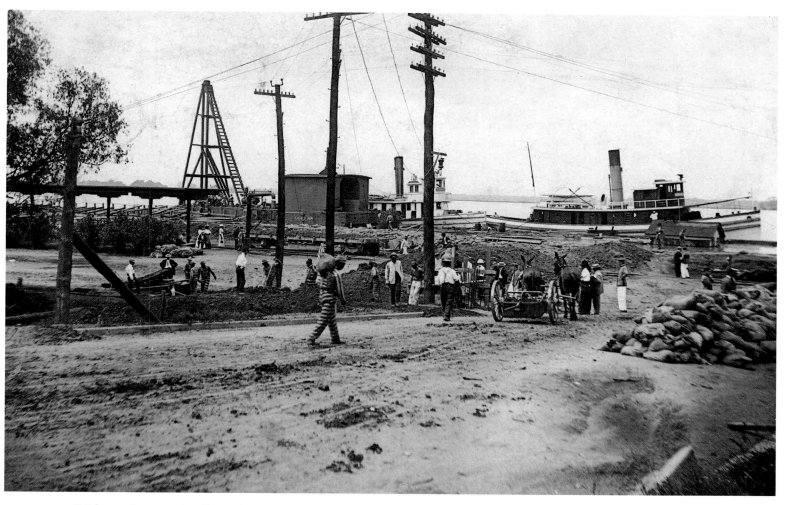

Without a levee until well into the twentieth century, Baton Rouge experienced periodic flooding by the Mississippi River. Sandbagging and temporary flood walls were the standard defense. Prisoners from the state penitentiary proved a ready source of conscripted labor during high-water emergencies, as this image from around 1897 demonstrates.

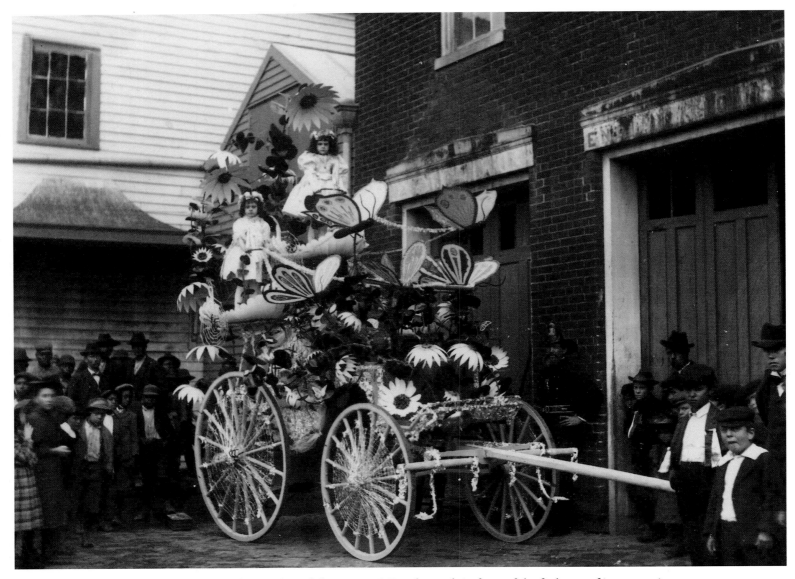

A highly decorated float for the annual Washington's Birthday Firemen's Parade stands in front of the firehouse of its sponsoring volunteer fire company.

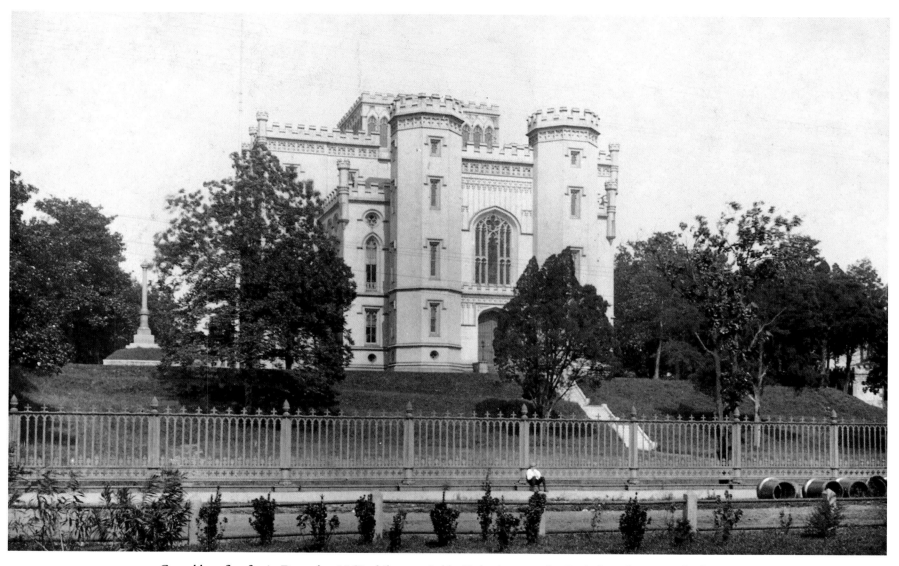

Gutted by a flue fire in December 1862 while occupied by Federal troops, the Capitol was later completely reconstructed under the direction of architect and engineer William A. Freret. The reconstruction was completed in 1882. This shot of the west side of the structure, taken from River Road about 1890, provides an excellent view of the cast-iron fence surrounding the grounds.

The Pelican Hook and Ladder Company No. 1 proudly displays its new ladder truck in this image from around 1895. Company members and other citizens stand outside the Pelican firehouse located at 78 Third Street in downtown Baton Rouge.

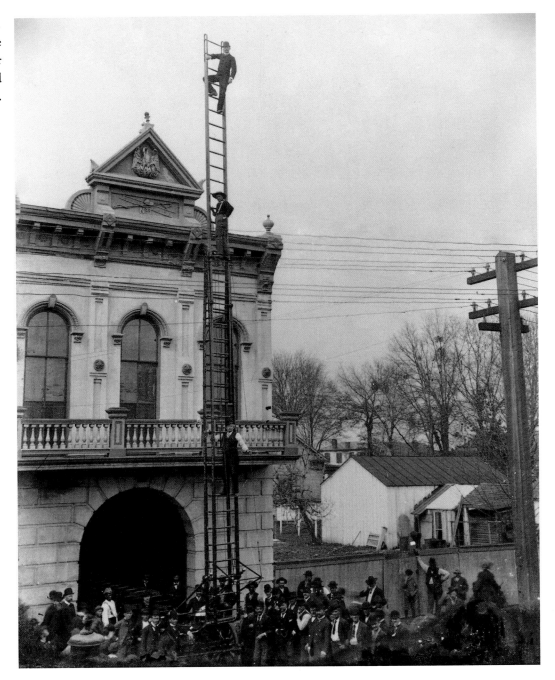

FOOTBALL AND A STRONG ECONOMY

(1900–1919)

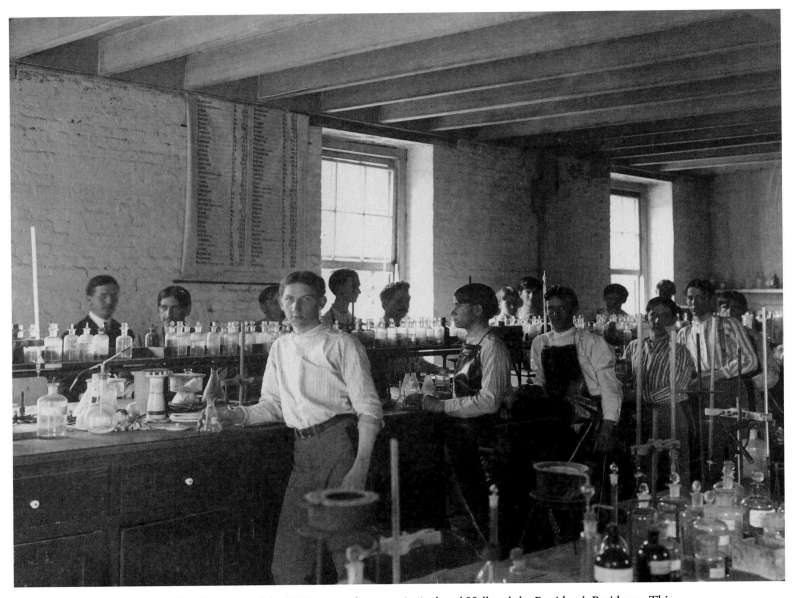

The Chemical Laboratory stood in the center of the LSU campus between Agricultural Hall and the President's Residence. This interior view of the laboratory, photographed around 1900, shows cadets poised for experimentation.

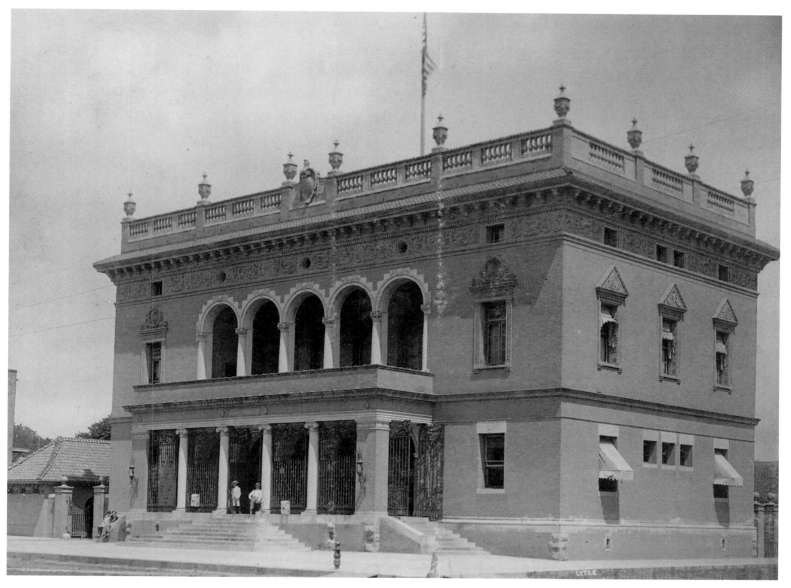

A new main post office and federal courthouse, completed in 1894 on North Boulevard between Third and Fourth streets in downtown Baton Rouge, served the growing community for decades. Seen here around 1900, its Italian Renaissance facade added interesting variety to the downtown architecture.

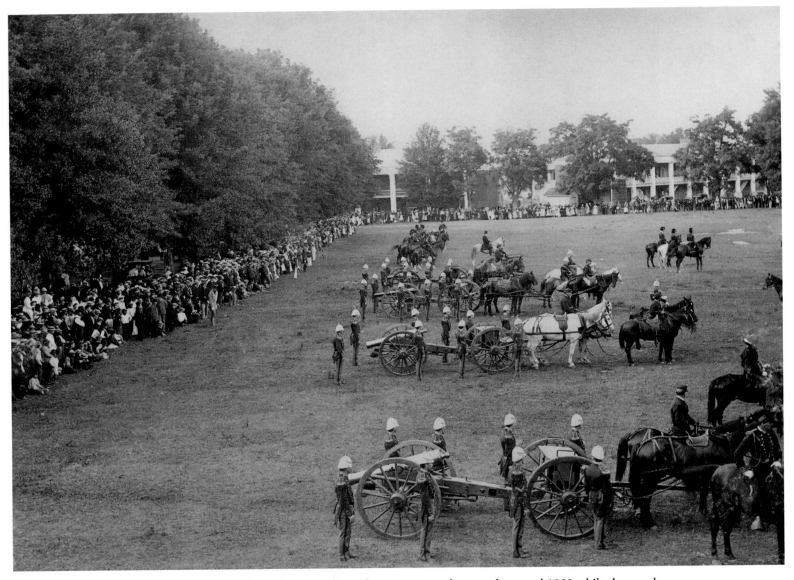

The cadets of Louisiana State University conduct a dress parade on the campus parade grounds around 1900 while the people of Baton Rouge look on.

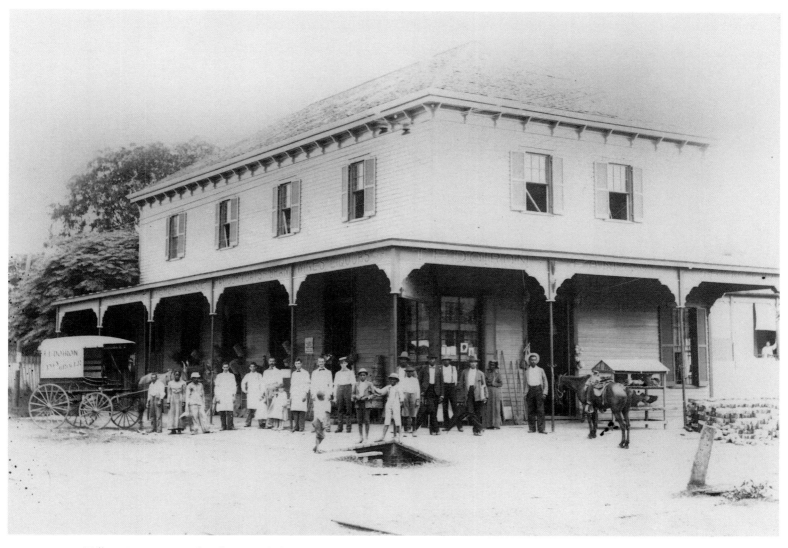

Tolbert Doiron owned and operated this grocery and liquor store at 617 Government Street. In 1906, within a few years of this image, there were 75 retail grocers in Baton Rouge.

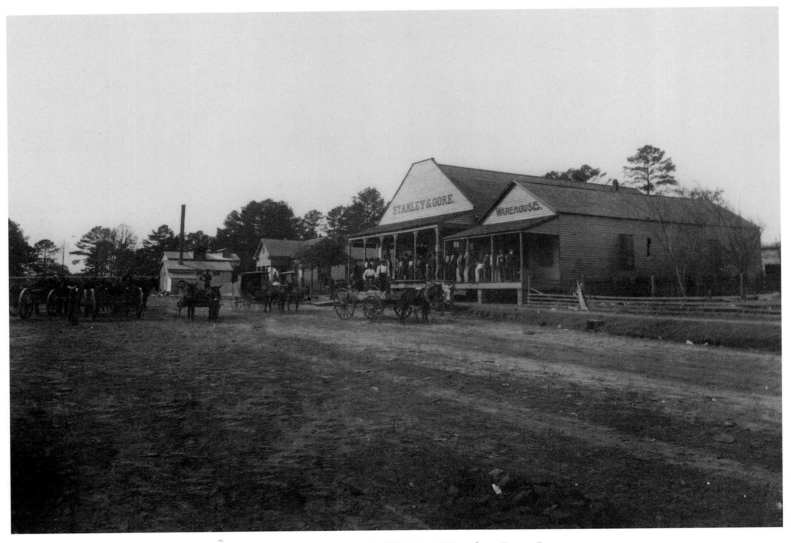

The Stanley & Gore store and warehouse served a plantation across the Mississippi River from Baton Rouge.

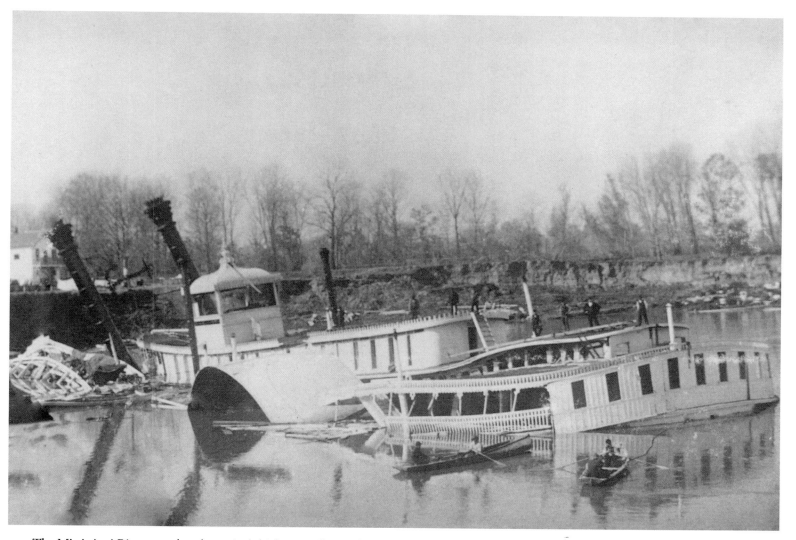

The Mississippi River served as the nation's highway well into the twentieth century. Hundreds of steamboats plied the river making hundreds of thousands of trips along the entire navigable reach of the river system, not all successfully. This scene from around 1900 demonstrates how many steamboats came to an end as wreckage partially sunken along the shore.

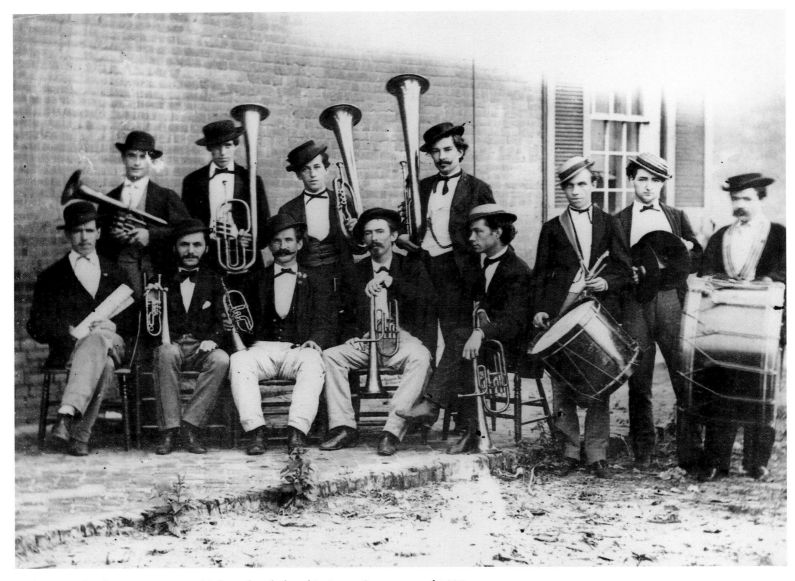

A glimpse at local entertainment—this brass band played in Baton Rouge around 1900.

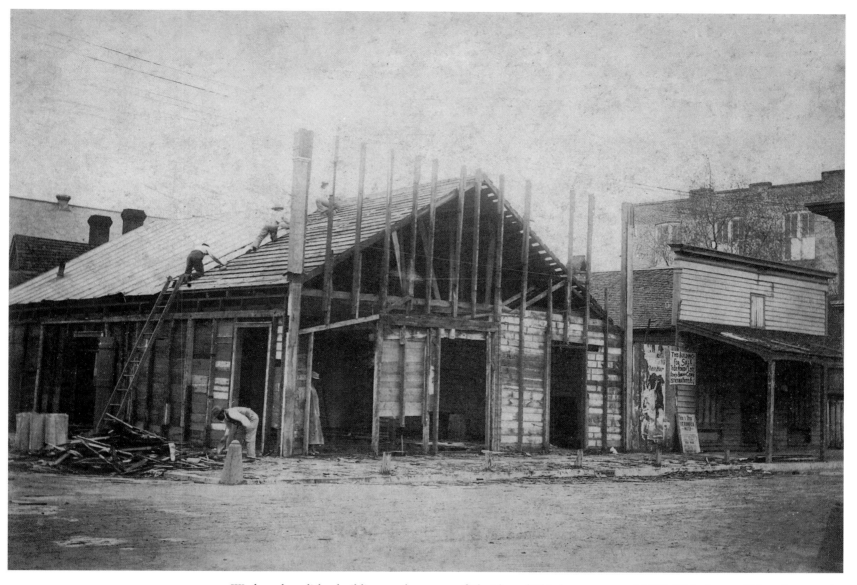

Workers demolish a building on the corner of Florida and Third streets around 1900. This site would later become the home of the Istrouma Hotel.

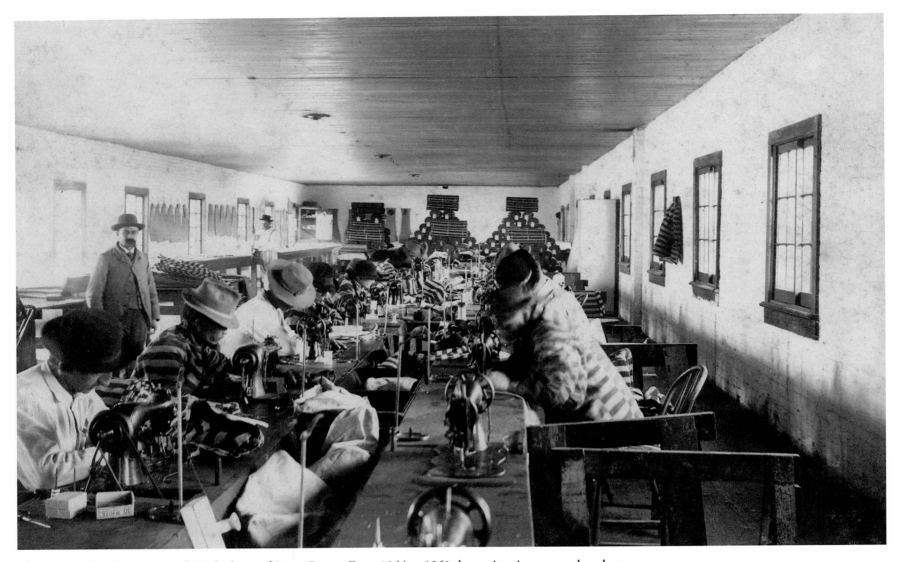

The state penitentiary sat squarely in the heart of Baton Rouge. From 1844 to 1861 the penitentiary ran under a lease held by a private firm. Beginning in 1869, the lease was awarded to Confederate major Samuel James, who held the lease through 1900. On January 1, 1901, the State of Louisiana resumed control of all inmates. This image from around 1905 shows inmates working in the penitentiary's clothing factory.

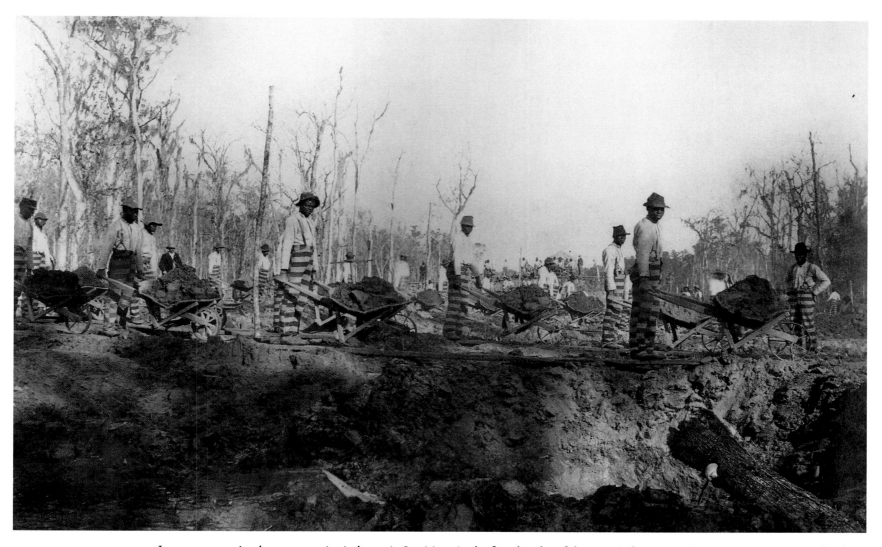

Levee construction became a major industry in Louisiana in the first decades of the twentieth century. State prisoners represented a cheap source of labor often leased to private contractors. Here around 1905, prison laborers push wheelbarrows full of dirt used to construct a levee somewhere near Baton Rouge.

John B. Heroman lived his entire life in Baton Rouge. He entered many photography contests, and for one of them he provided this view of the town around 1910. While the front banner extols the quality of Baton Rouge water, the banner down the street reads: "Baton Rouge is moving, watch it grow from 25,000 to 50,000 in the next 5 years, the place for factories."

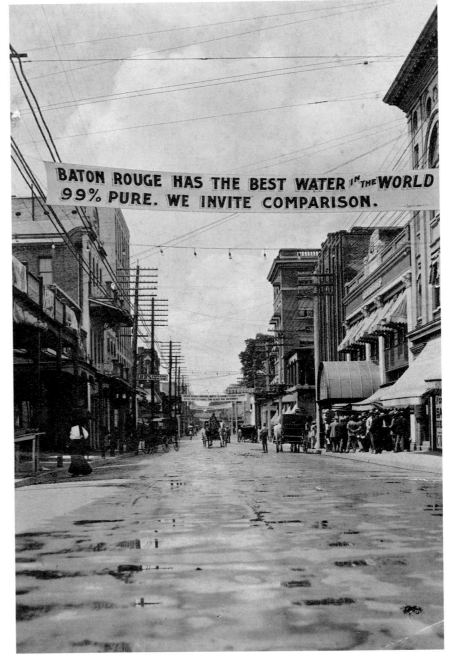

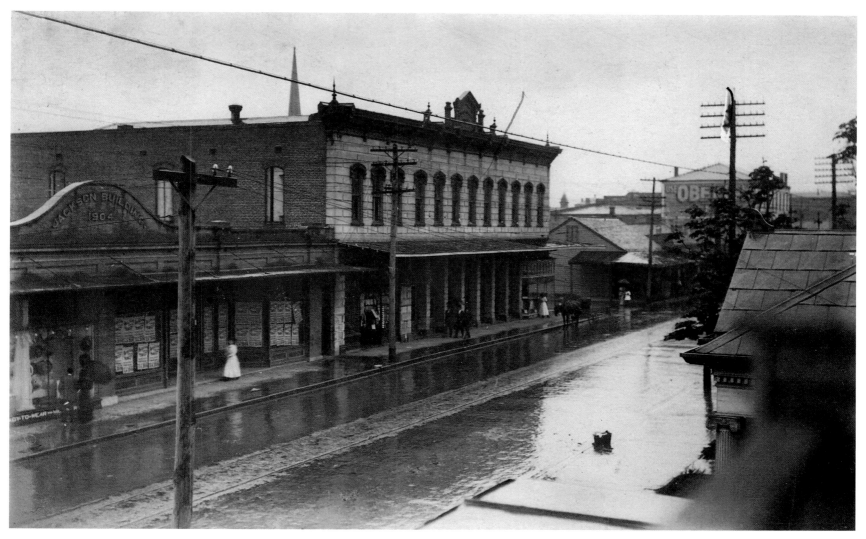

A rainy day in downtown Baton Rouge attracted the eye of photographer John B. Heroman sometime around 1910. As the power poles testify, the town had begun to be wired for electric service by then.

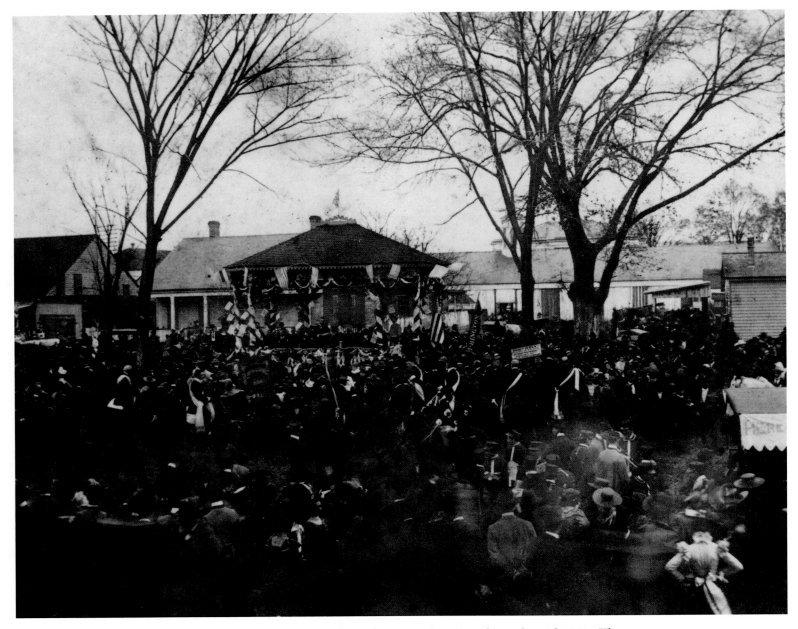

The annual Washington's Birthday Firemen's Parade began in the mid-1870s and continued into the mid-1910s. The crowd in this scene from around 1910 is gathered at the Public Market downtown near the Capitol.

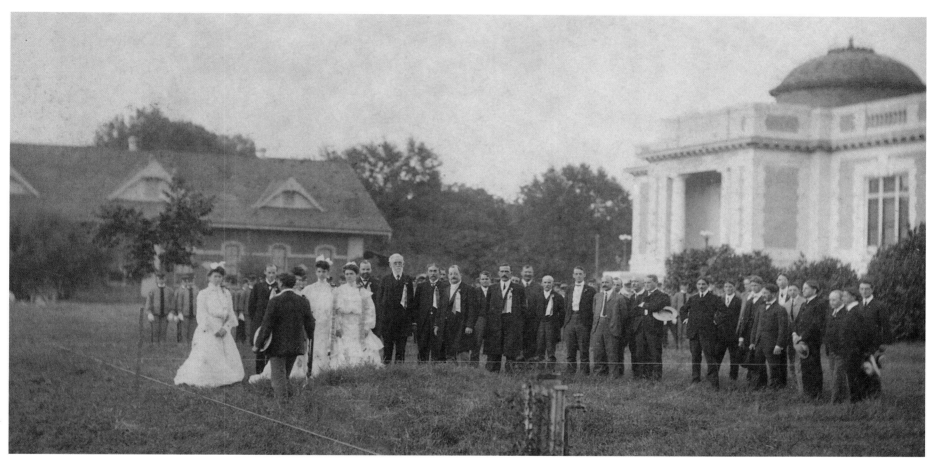

Here in September 1903, guests of honor, faculty, and cadets attend the ground-breaking for the Alumni Memorial Hall at Louisiana State University. At right stands Hill Memorial Library; behind the group is Garig Hall. When the university moved to its current site, the facade of the Alumni Hall was disassembled, moved to the new site, and reconstructed as the facade of the School of Journalism.

At the time of this image, around 1903, the Arsenal grounds had long since been transferred to the state and become the campus of Louisiana State University. "The Alley" ran from Lafayette Street to A Building, one of the Pentagon Barracks used for classrooms and a dormitory. The Professor's Residence can be seen at left.

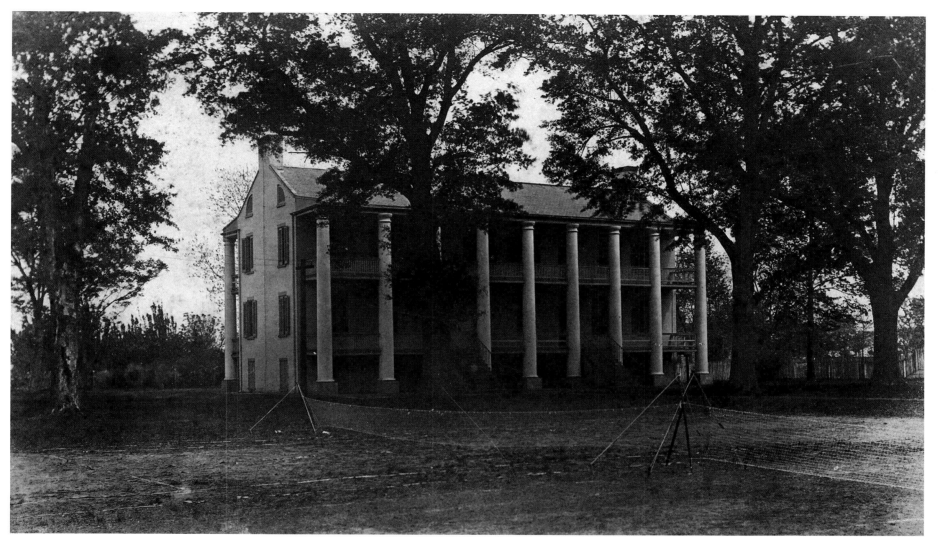

This building, the "Colony," served as an LSU dormitory. Evidently, the sport of lawn tennis had been introduced to the campus by 1903, with courts established near the dormitory.

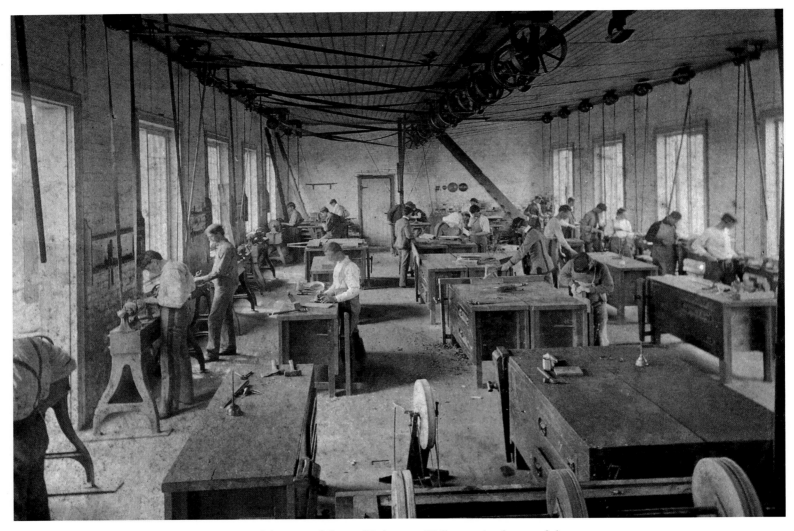

The LSU woodworking shop, occupying part of the ground floor of Robertson Hall, contained state-of-the-art equipment for 1903. A forge, foundry, and machine shop occupied the rest of the floor.

Louisiana State University and the Louisiana State Agricultural and Mechanical College merged under an act of the state legislature in 1877. The offices of the Agriculture Experiment Station moved into this LSU campus building, seen around 1905, from Audubon Park in New Orleans.

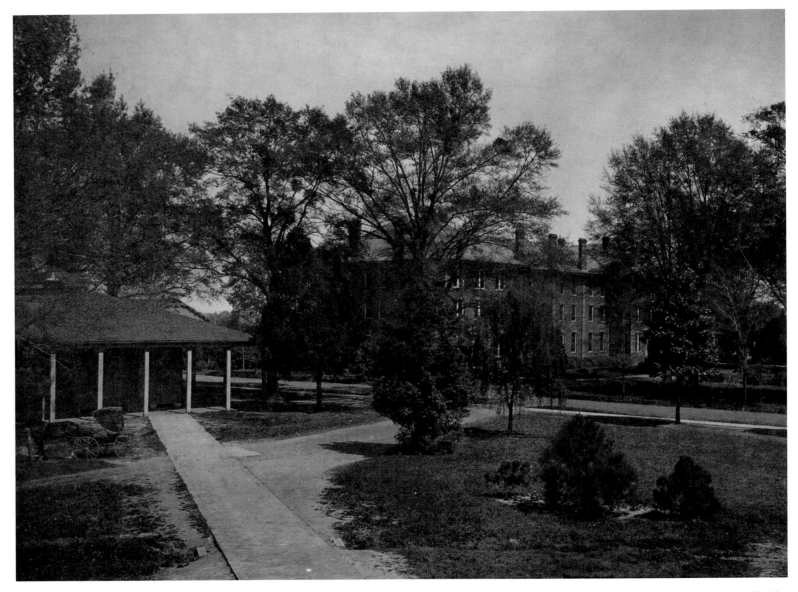

The university campus expanded greatly in the early 1900s. Foster Hall, at right, served as a dormitory and dining hall. The hospital, at left, looked after the cadets' health and well-being.

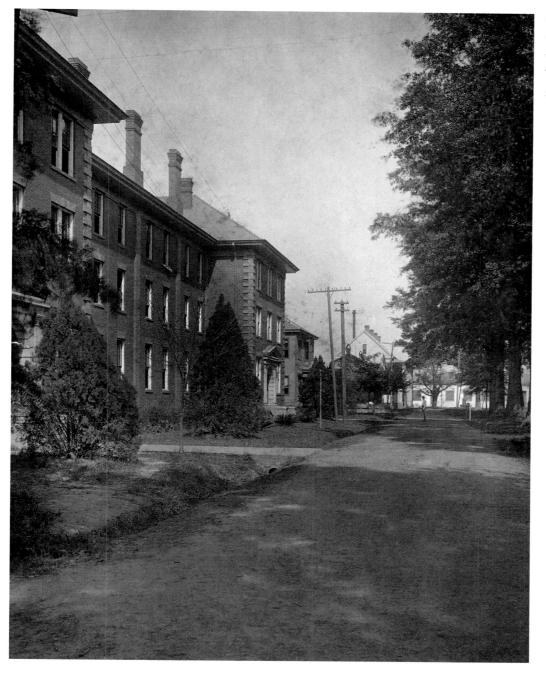

Over time, the old Arsenal grounds were transformed by the growth of the university. This view from around 1905 features Foster Hall, the Treasurer's Office, and, at the end of the street, a machine shop building.

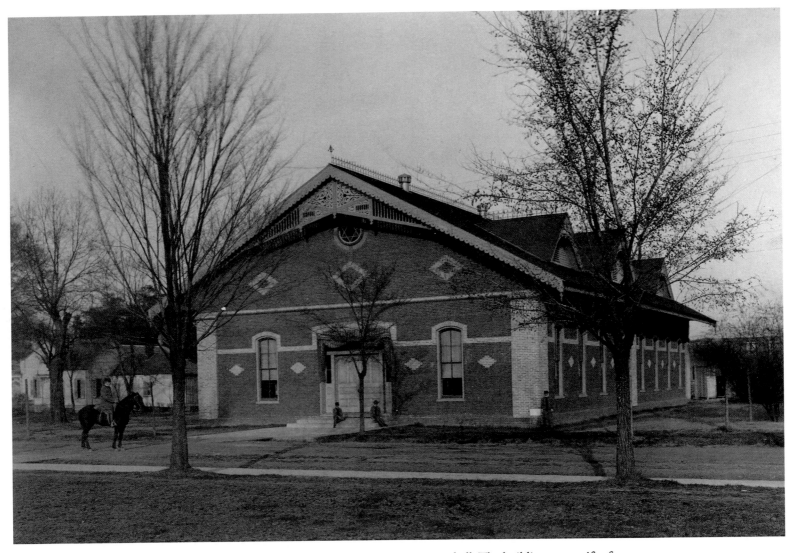

Able to hold 1,200 persons, LSU's Garig Hall, built 1899–1900, served as a meeting hall. The building was a gift of William Garig and is seen here around 1905.

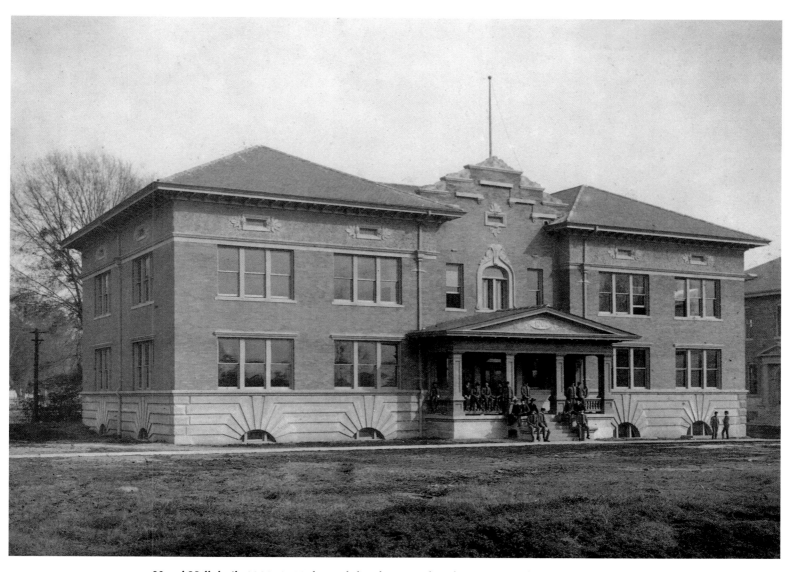

Heard Hall, built 1902–1903, housed the physics and civil engineering departments at the university. Occupying the first floor, the Department of Physics and Electricity maintained a laboratory specially designed for the study of magnetism. The Department of Civil Engineering occupied the second floor.

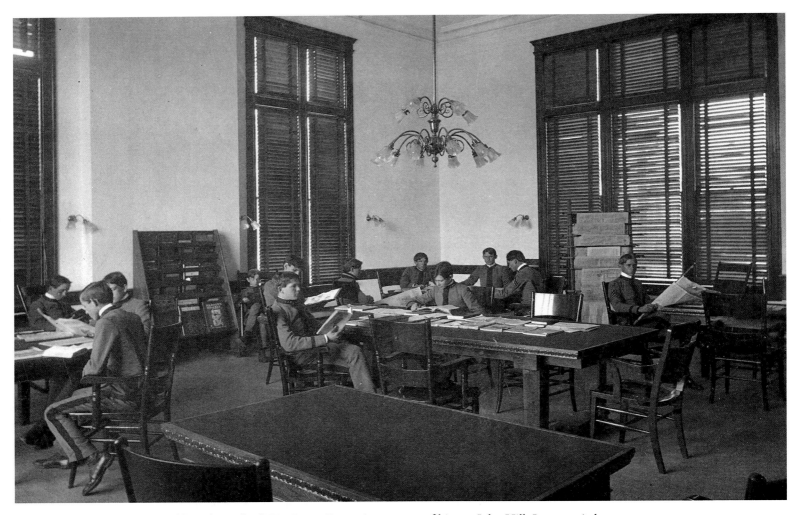

Hill Memorial Library, donated by John Hill of West Baton Rouge in memory of his son John Hill, Jr., occupied a prominent position on the LSU campus near the Third Street entrance. Its central rotunda was flanked by two reading rooms, one of which these studious cadets are utilizing around 1905.

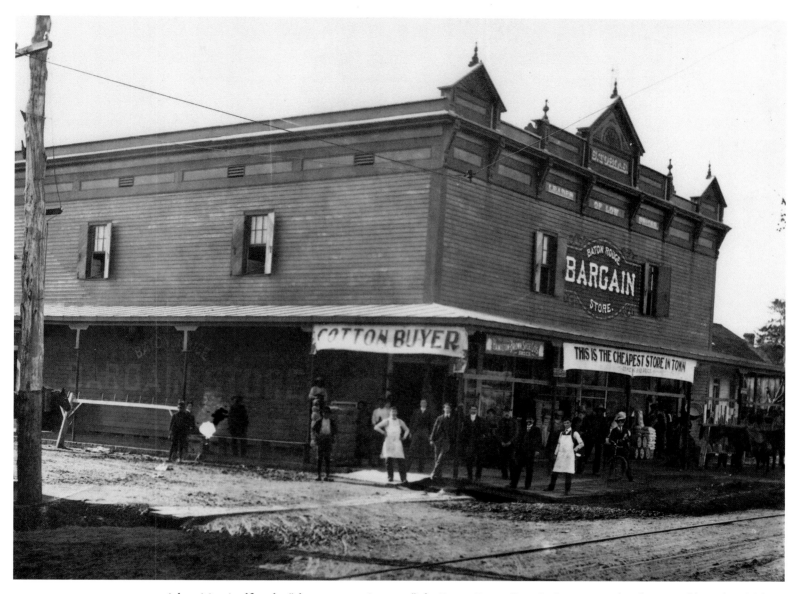

Advertising itself as the "cheapest store in town," the Baton Rouge Bargain Store, owned and operated by Sylvan Tobias, provided the citizens of Baton Rouge with a variety of goods. This image appears in the *Elks' souvenir of Baton Rouge; containing an historic, commercial and industrial review of prominent advantages of Parish of East Baton Rouge and the flower city of Louisiana,* published in 1901.

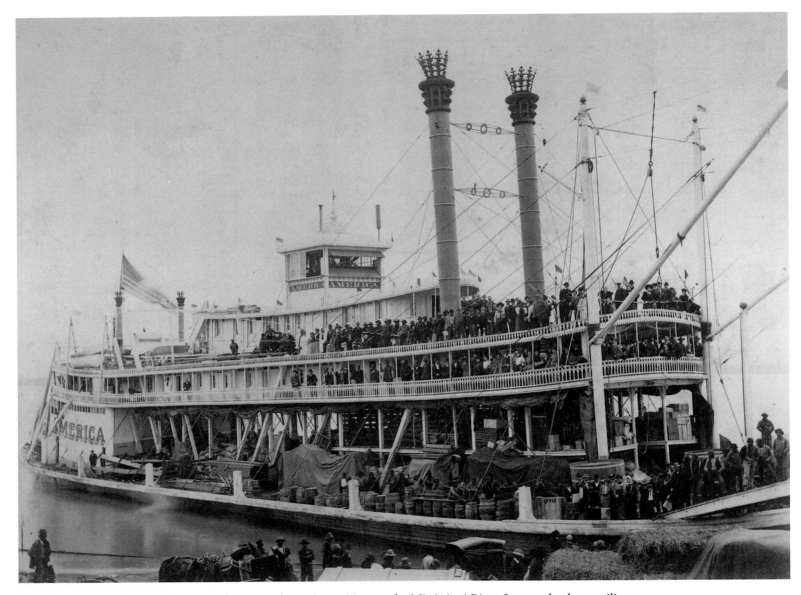

Baton Rouge grew through the years in large part due to its position on the Mississippi River. It was valued as a military post because of its command of the river and its natural harbor. These attributes grew in significance over time as the United States became established and trade developed. By the late 1800s, Baton Rouge had become an important entrepôt for steam-powered riverboats like the *America,* seen here around 1900.

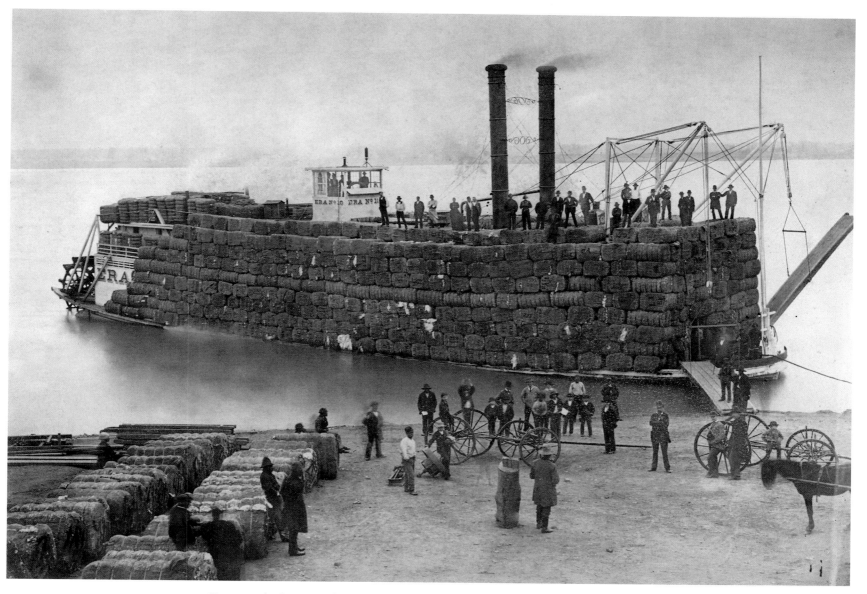

Cotton and other agricultural crops had always been important to the economy of the lower Mississippi Valley. Well into the late 1800s, cotton remained an important commodity. The *Era No. 10,* seen anchored off Baton Rouge around 1900, is so fully loaded with cotton bales that it has no freeboard.

Looking from the intersection of Main and Fifth streets around 1910, Samuel T. Dupuy's Pharmacy, 522 Main, is on the corner at right, diagonally across from William Meyerer's grocery and bar at 601 Main.

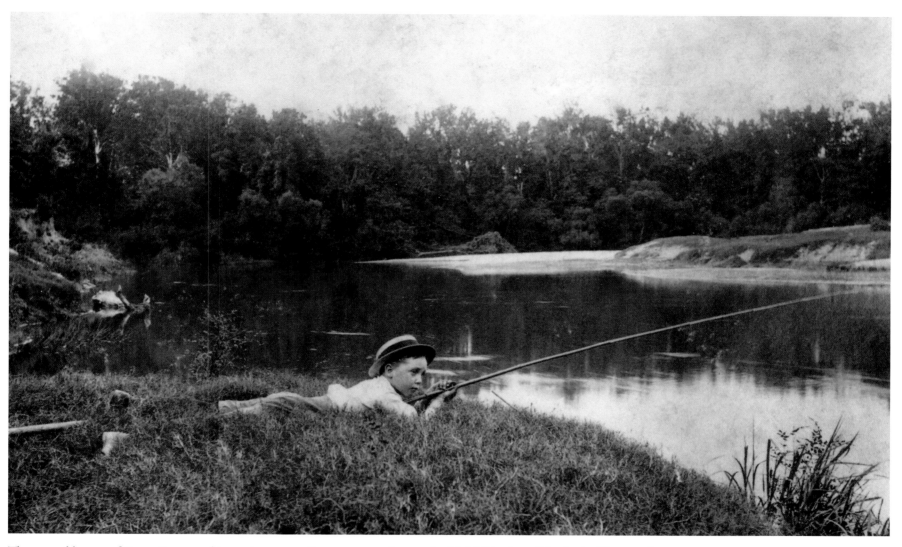

The natural beauty of Baton Rouge and its environs was often commented upon. In this idyllic view of the Amite River on the eastern edge of East Baton Rouge Parish, the hopeful fisherman is Andrew D. Lytle, Jr., photographed around 1900 by Howard Lytle, son of the senior Andrew D. Lytle and partner in his Lytle Studio.

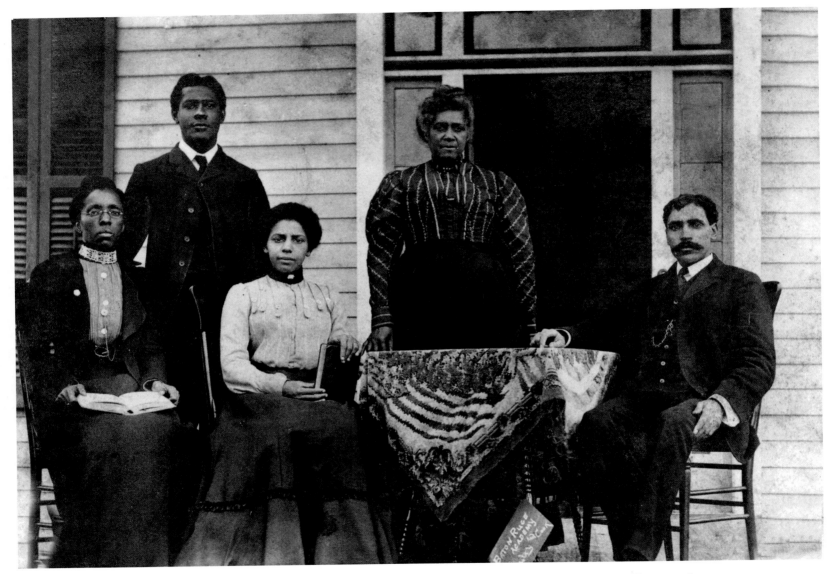

The Baton Rouge Academy was one of five private schools and colleges for African-American citizens of Baton Rouge. Here, members of the faculty pose for a group portrait on the porch of the academy, located at 125 Middle Highland Road, around 1910.

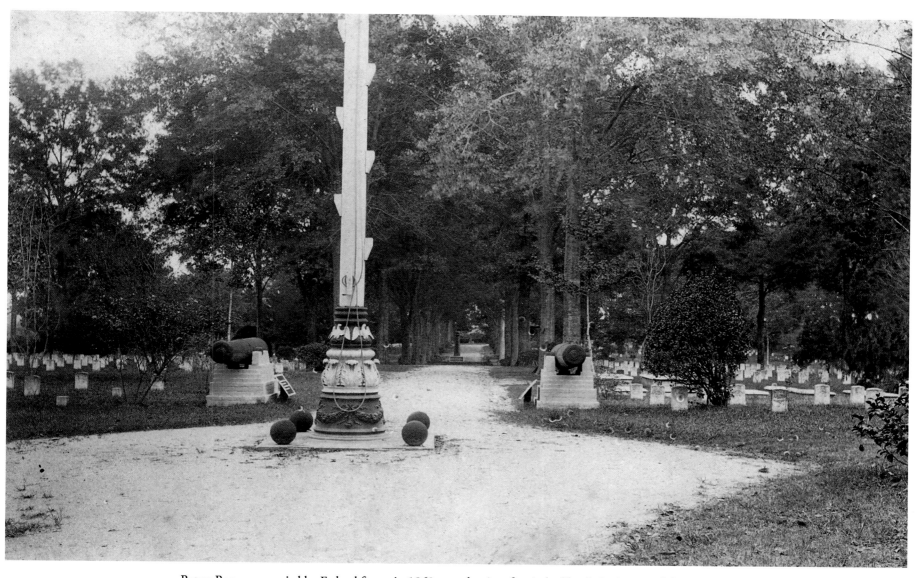

Baton Rouge, occupied by Federal forces in 1862, was the site of a pitched battle in August of that year. Slain soldiers and sailors were buried near Magnolia Cemetery on the outskirts of town. Fifty years after the Civil War ended, the National Cemetery in Baton Rouge began to receive monuments to Northern soldiers and sailors. This image of the National Cemetery from around 1910 shows one such monument.

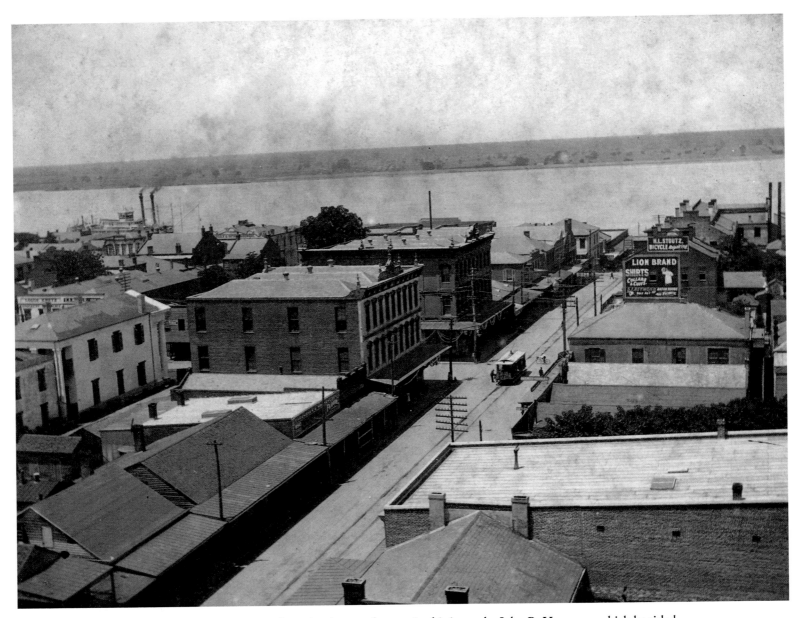

The first four blocks of Main Street as it runs east from the river can be seen in this image by John B. Heroman, which he titled "My home town" for submission to a photo contest around 1910.

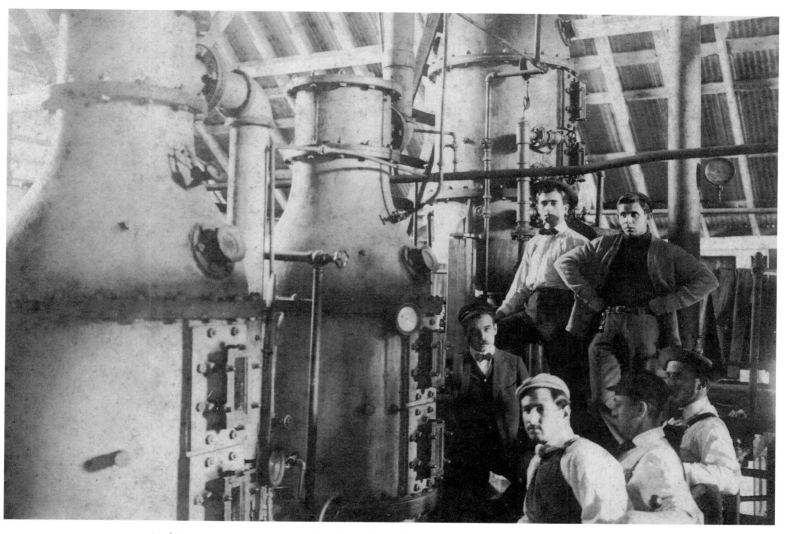

As this scene suggests, the Audubon Sugar School played a strong role in research and development for the sugar industry in Louisiana. Making sugar from cane juice requires separating the sugar from the water carrying it; traditionally, this was accomplished by boiling off the water in open pans or kettles. Here, classmen stand around an experimental evaporator operating under vacuum, thereby saving energy by allowing the water to evaporate at temperatures below 212 degrees Fahrenheit.

A delegation from Massachusetts came to Baton Rouge for three days in November 1909 to dedicate the monument Massachusetts had erected in the National Cemetery to honor soldiers from that state who lost their lives in the battle of Baton Rouge and were buried here. This image, created by Teunisson Studio of New Orleans, shows the delegation at the monument.

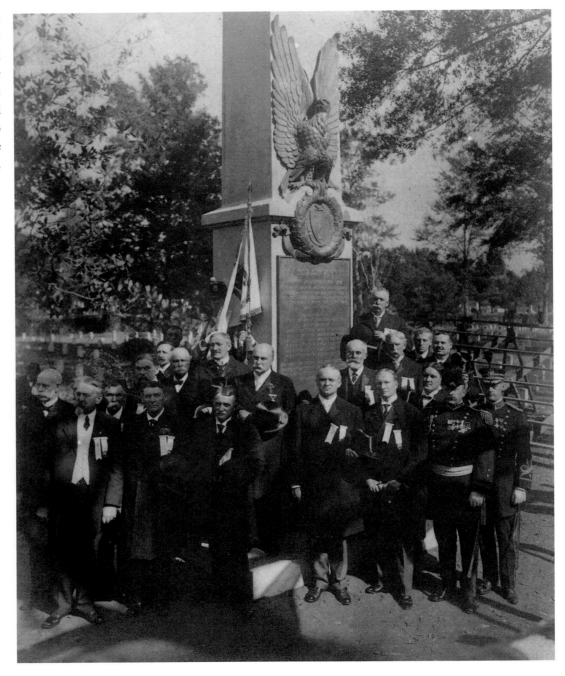

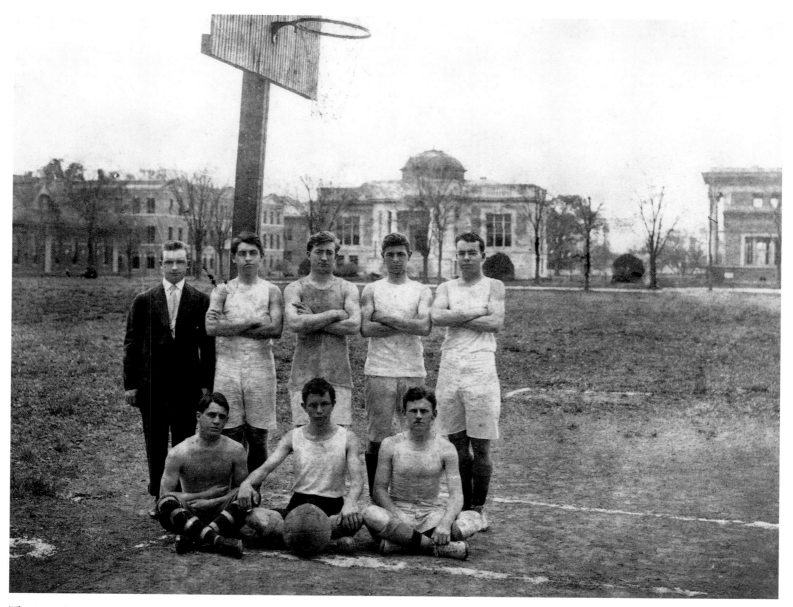

The 1909 Louisiana State University basketball team posed for this group portrait on the athletic field of the old Arsenal campus downtown. Immediately behind the team is Hill Memorial Library.

Before the levee was built to protect Baton Rouge, town citizens, through hard-won experience, created innovative, temporary structures to accommodate high-water episodes, such as occurred in both 1915 and 1917. This scene demonstrates the townspeople's skills.

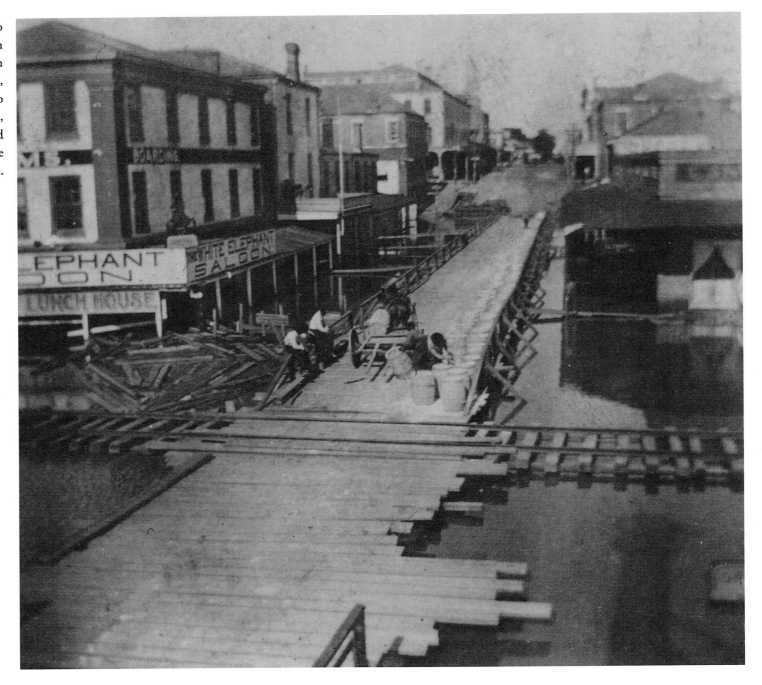

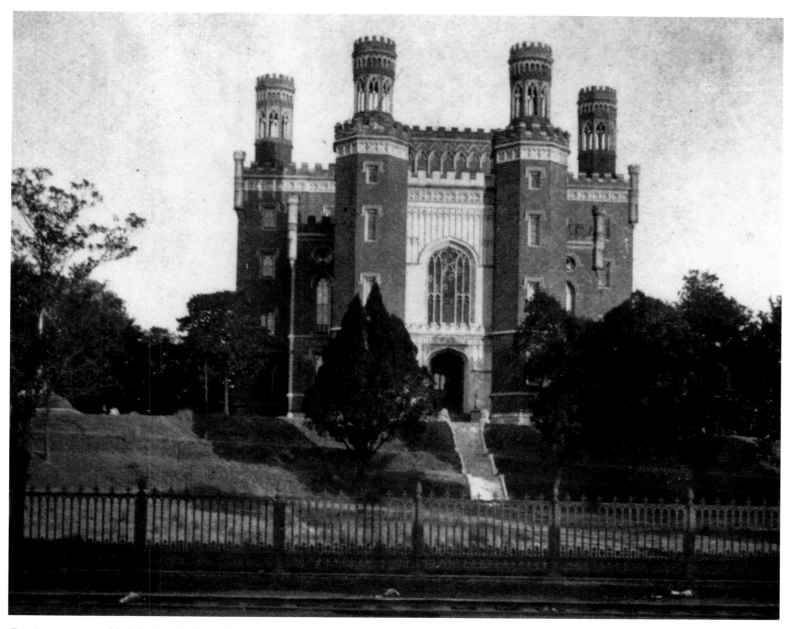

Cast-iron turrets, added during the Capitol's reconstruction under the direction of William A. Freret in the 1880s, added a new dimension to Dakin's castellated Gothic style. The turrets would be removed in 1917 following their partial destruction by a tornado.

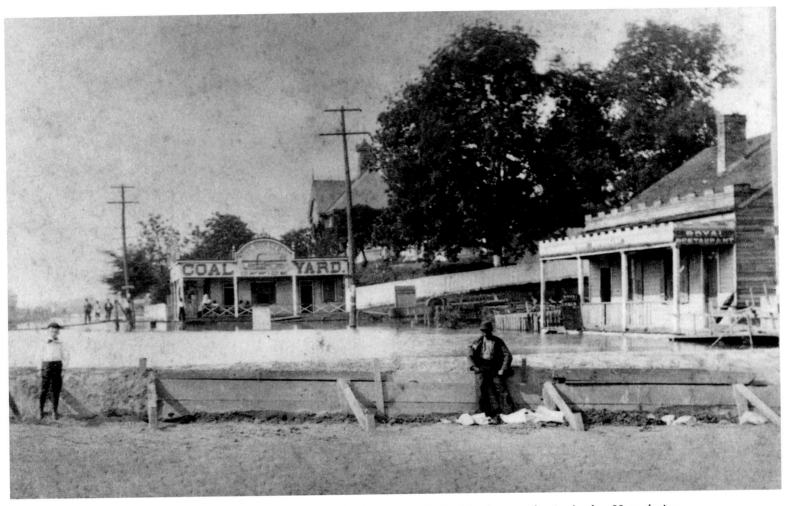

Despite periodic flooding by the Mississippi River, Baton Rouge businesses were built right down to the river's edge. Here, during the flood of either 1915 or 1917, temporary measures were taken to limit the spread of floodwaters.

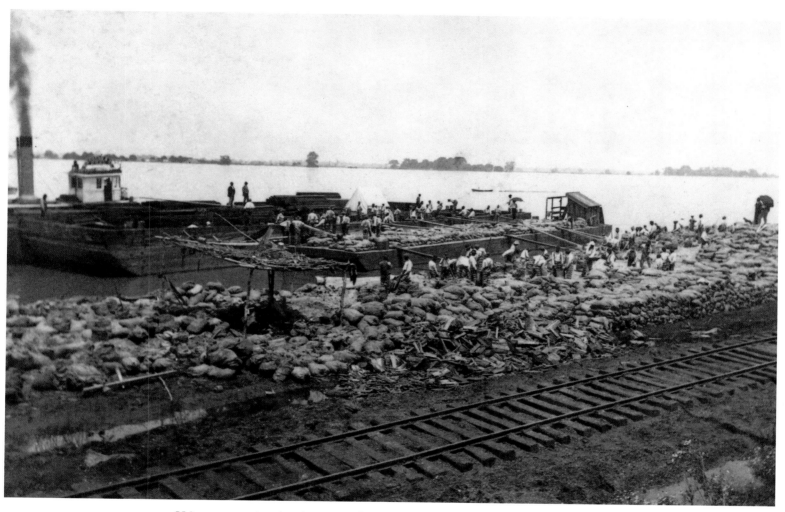

Using state penitentiary inmates to lay sandbags during flood events was a common practice in Baton Rouge. In this scene from 1915 or 1917, the flood was attacked from both land and water.

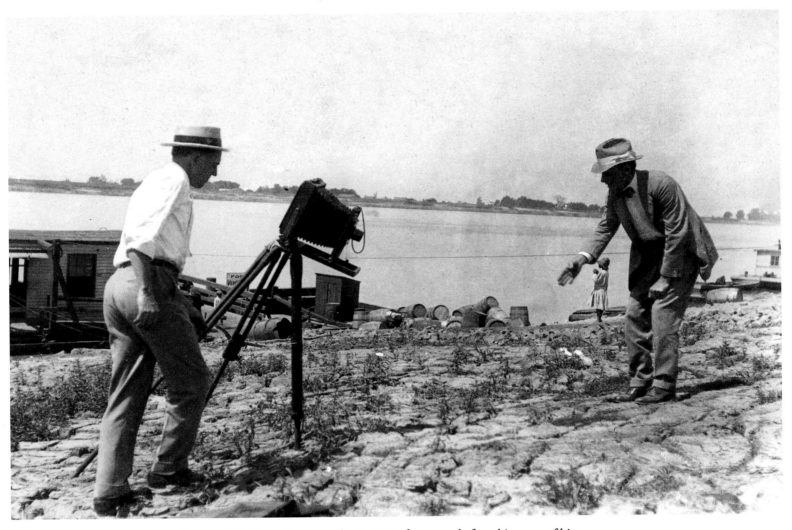

Photographer Jasper Ewing, at left, started his Baton Rouge studio in 1912, four years before this scene of him photographing cracks in the levee along the Mississippi River.

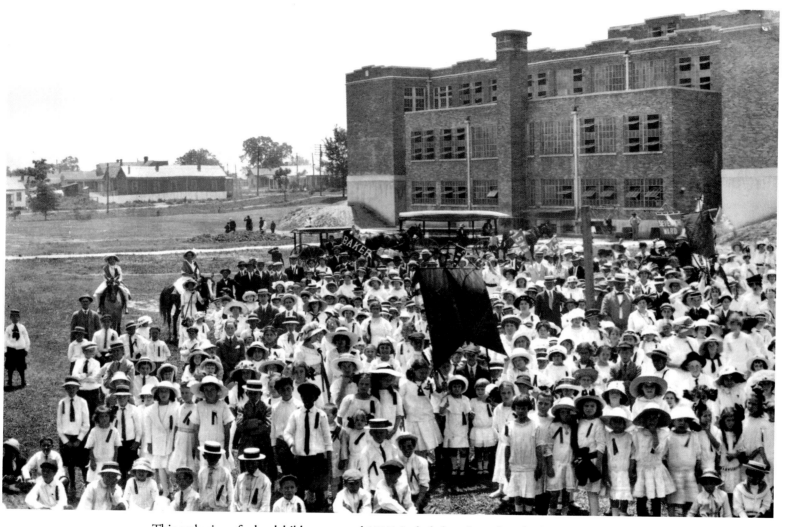

This gathering of schoolchildren, around 1917, included students from both public and private schools in Baton Rouge.

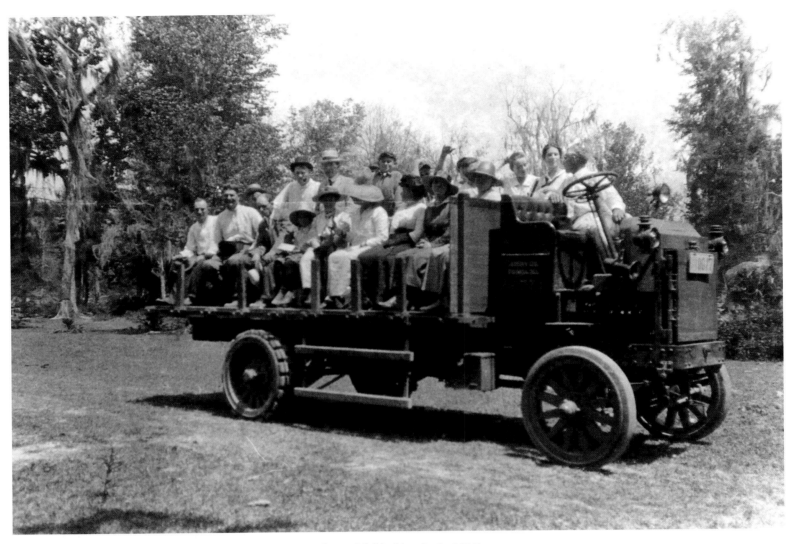

Faculty members from Louisiana State University enjoy a ride to pick blackberries in 1917.

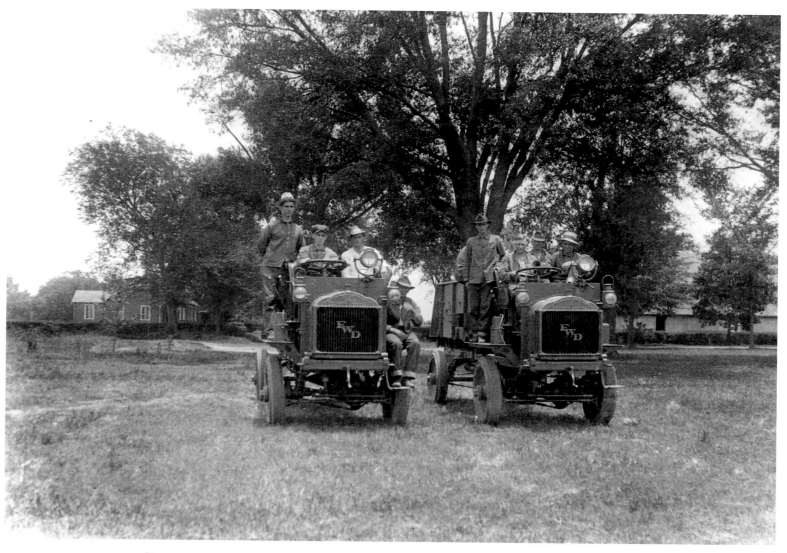

Given Baton Rouge's long history as a military outpost, it is no surprise the area served in that capacity again during World War I. These two vehicles were used as Army ammunition trucks.

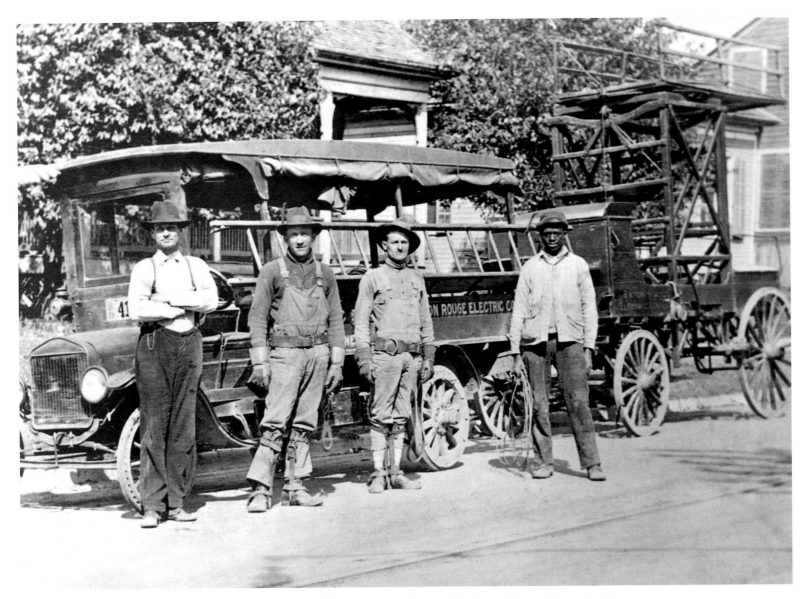

The Baton Rouge Electric Company, established in 1907 following the purchase of the Baton Rouge Electric & Gas Company by Stone & Webster Engineering Corporation, provided service to the Baton Rouge area until the late 1930s when it became part of the Gulf States Utility Company. Repair crew members Cap Denham, Cecil Collins, F. F. "Blondie" Gaines, and Lee Brown pose beside their truck around 1918.

A New Campus and a Terrible Flood

(1920–1929)

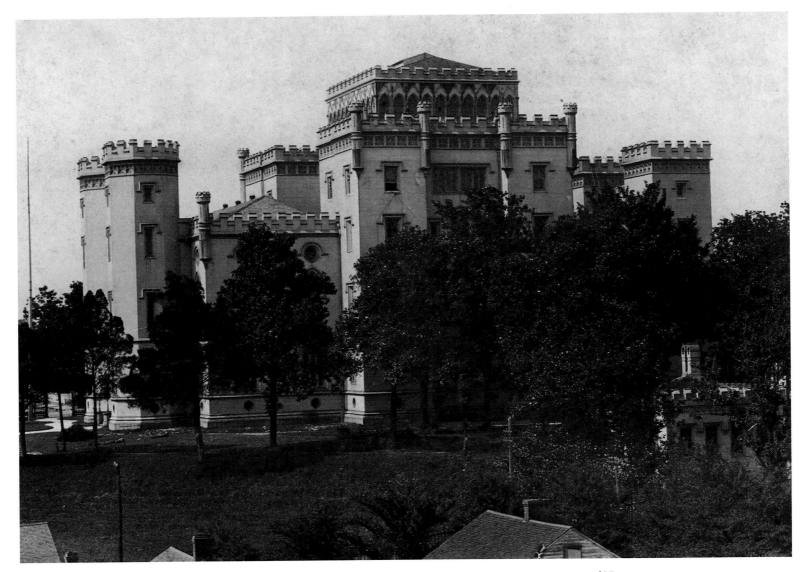

The capitol served as an anchor for the Beauregard Town neighborhood. Originally laid out in 1809, Beauregard Town was intended to be the center of state government, though that plan was never realized. Sited on the northwest corner of the district, the capitol stood surrounded on its east and south sides by the homes of Beauregard Town residents, as this view of the east facade around 1920 shows.

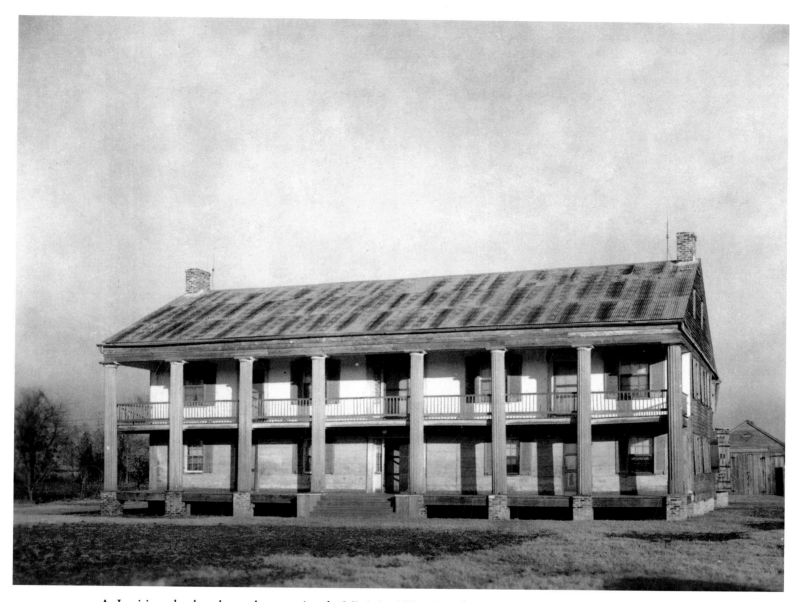

As Louisiana developed over the centuries, the Mississippi River, its tributaries, and its distributaries provided the surest access to the interior. The rich deltaic soils, built up over the centuries by regular flooding, proved rich and profitable to plantation owners, who would construct large homes for their families. Over time, with shifting fortunes, these homes often fell into disrepair. The Becnel Place plantation home, seen here around 1925, is one such example.

As Baton Rouge experienced tremendous growth in the early twentieth century, Third Street became the center of activity, with businesses, a movie theater, banks, and many other attractions. Facing south on Third from the intersection with Main, this view, about 1925, shows the sign for Capital Optical Company, 511 Third, on the right. Farther down the street is the S. H. Kress store at 439 Third.

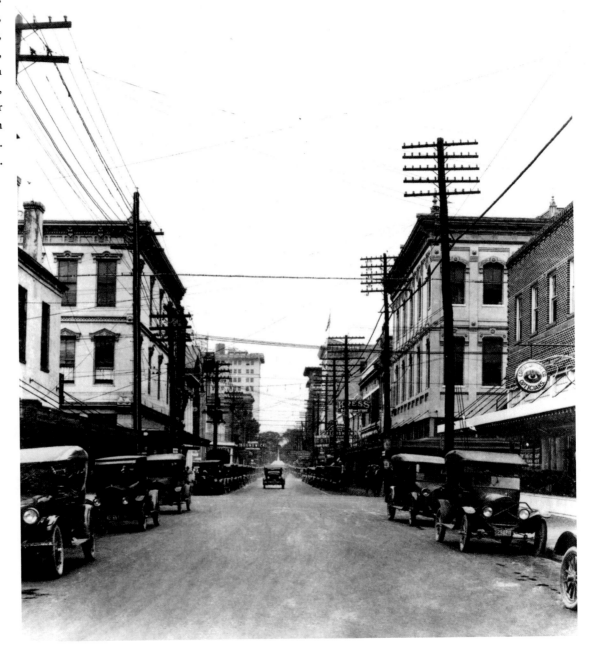

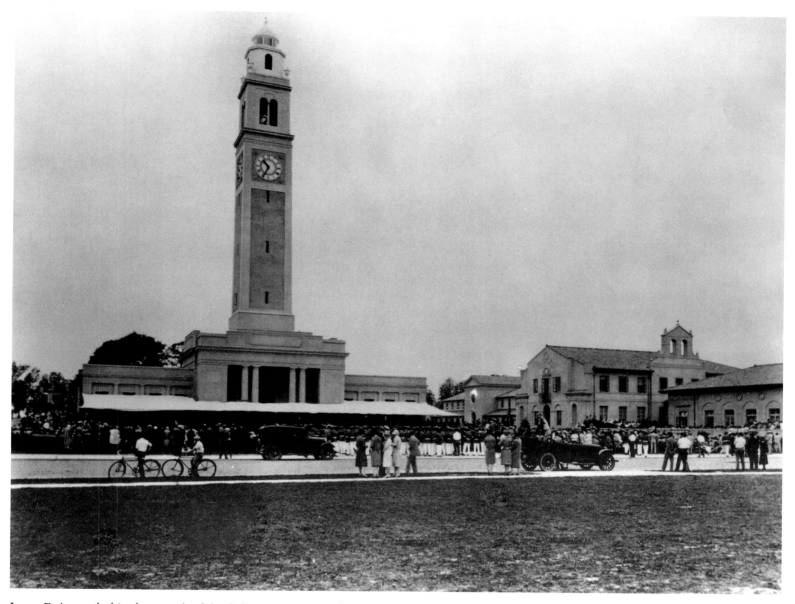

Jasper Ewing took this photograph of the dedication ceremony for LSU's new campus in 1926. The Memorial Tower, commemorating the university's military dead, stands to the left. Boyd Hall can be seen on the right.

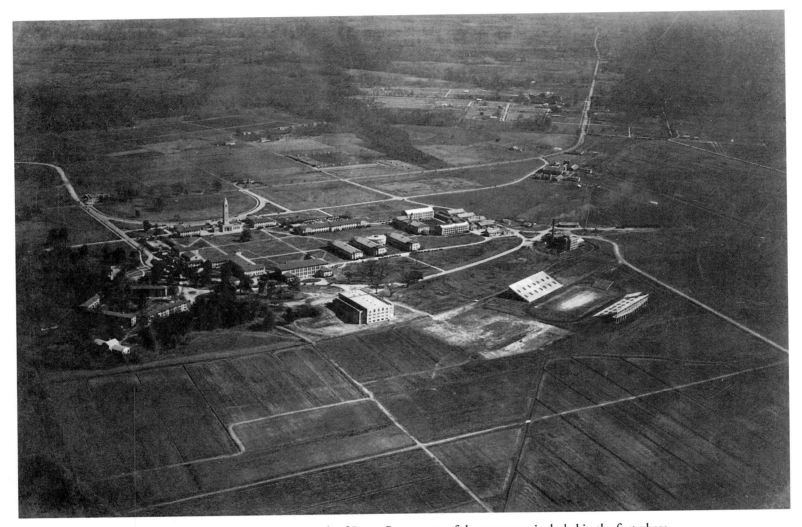

When Louisiana State University moved to its new site south of Baton Rouge, one of the structures included in the first phase of construction was the football stadium. In this phase, completed in 1924, only the east and west stands were finished. Initially seating around 12,000, Tiger Stadium would expand over the years. This aerial photograph of the campus provides an excellent overview of the original layout and design.

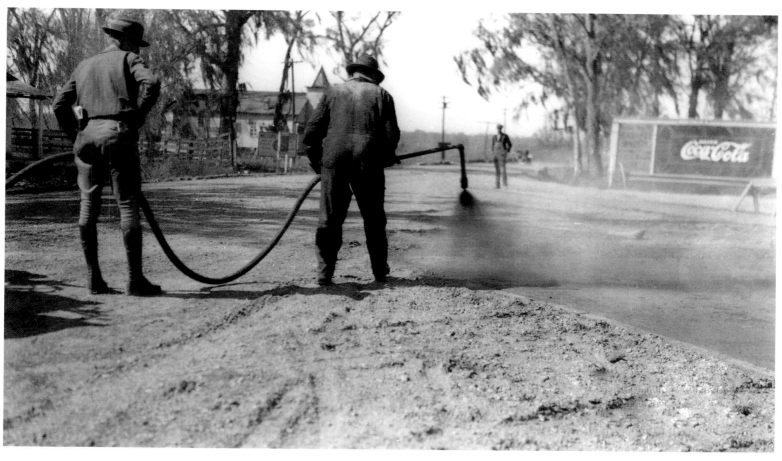

Louisiana had very few paved roads in the middle 1920s. This scene from February 1926 shows one step in the paving process, tarring the dirt road surface.

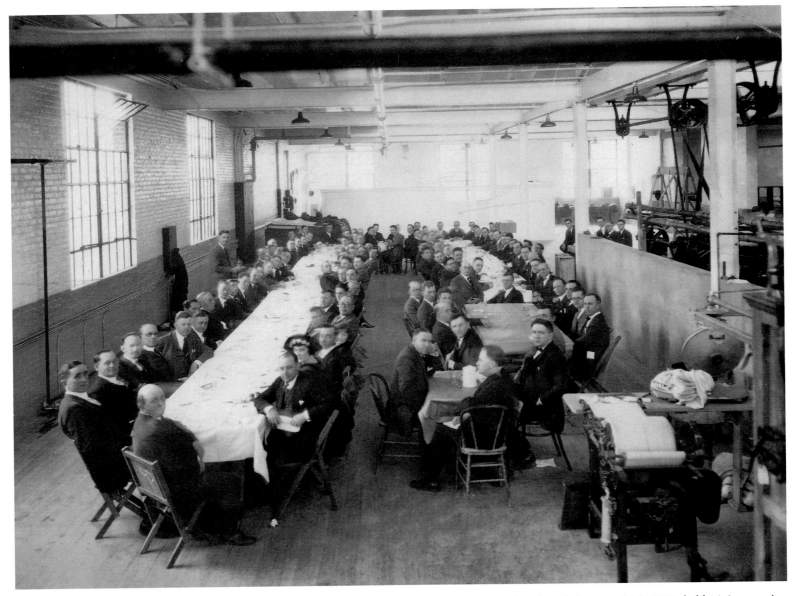

The Rotary Club of Baton Rouge, founded on October 1, 1918, and the Kiwanis Club, founded on April 24, 1919, held a joint meeting January 21, 1925, at the Southern Steam Laundry, 216 Third Street, owned and operated by brothers, J. Selby and Frank H. Kean.

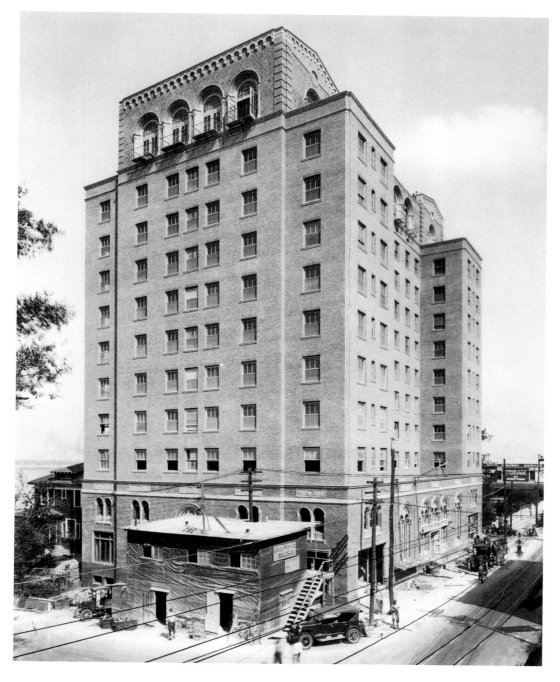

In September 1927, construction of the Heidelberg Hotel was drawing to a close at the corner of Lafayette and Convention streets, overlooking the Mississippi River. The hotel basement holds a "secret" entrance to a tunnel running under the street. Huey P. Long was rumored to have used this tunnel to sneak in and out of the Heidelberg unseen.

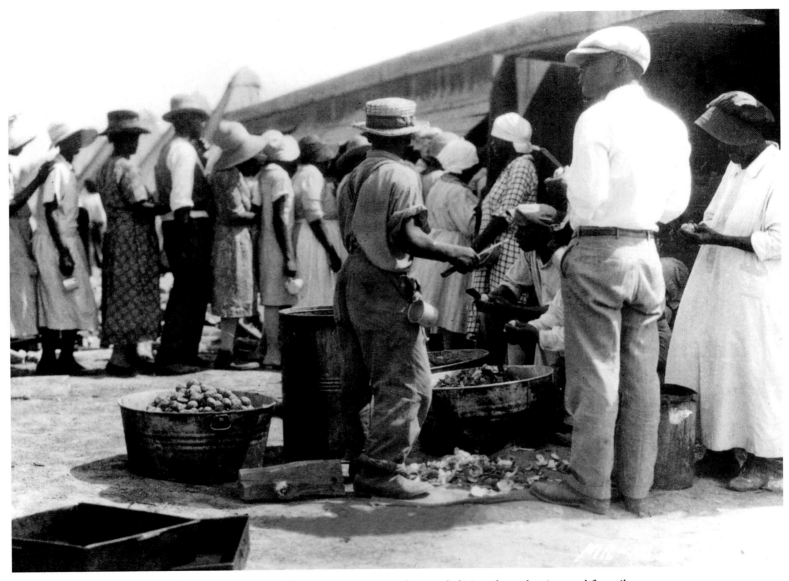

The Mississippi River flood of 1927 had a huge and devastating impact on the people living along the river and for miles inland. African-Americans, in particular, suffered, especially after the levees were dynamited upriver of New Orleans in an effort to protect that city. In this scene, food is distributed at a refugee camp near Baton Rouge.

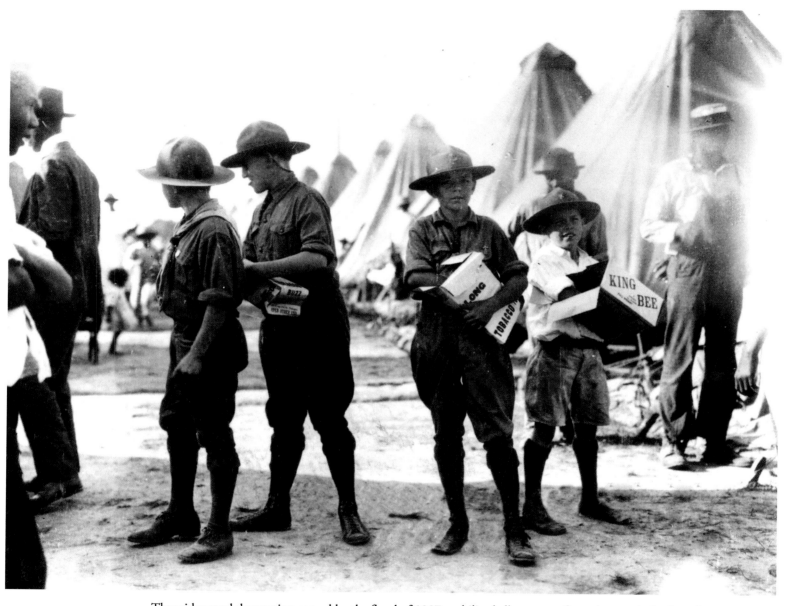

The widespread devastation caused by the flood of 1927 mobilized all manner of people to assist in the refugee camps. In this image, Boy Scouts help with distribution of tobacco at a camp near Baton Rouge.

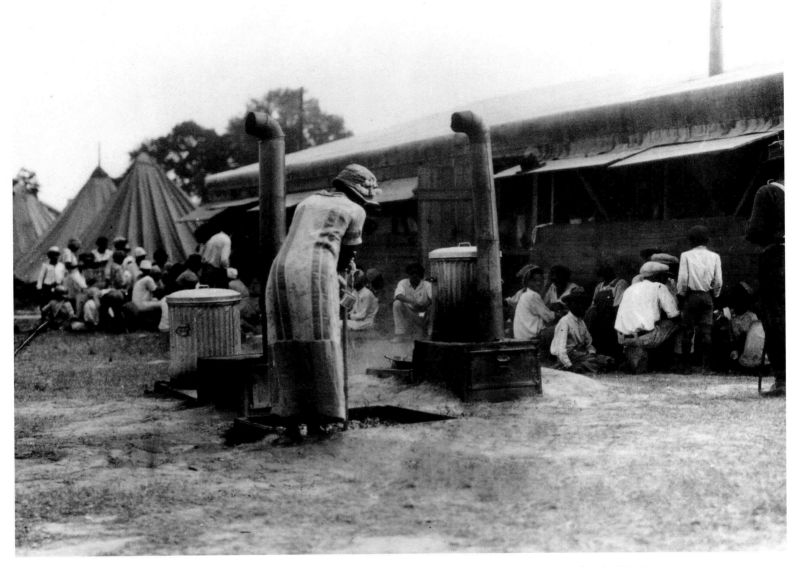

Conditions were harsh in the refugee camps filled with African-Americans displaced by the Mississippi River flood of 1927. Photographer Jasper Ewing documented this cooking facility in the camp on Jackson Road north of Baton Rouge.

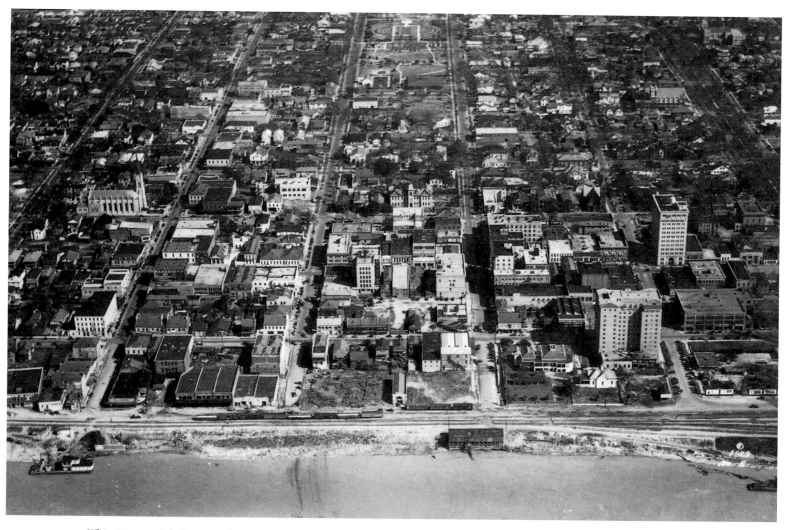

This 1929 aerial photograph of Baton Rouge shows the core of downtown. In the foreground, the railroad runs beside the Mississippi River, as yet without its levee. Saint Joseph's Cathedral, middle left, the Heidelberg Hotel and Auto Hotel, right foreground, and the 12-story Louisiana National Bank, right middle ground, all stand out.

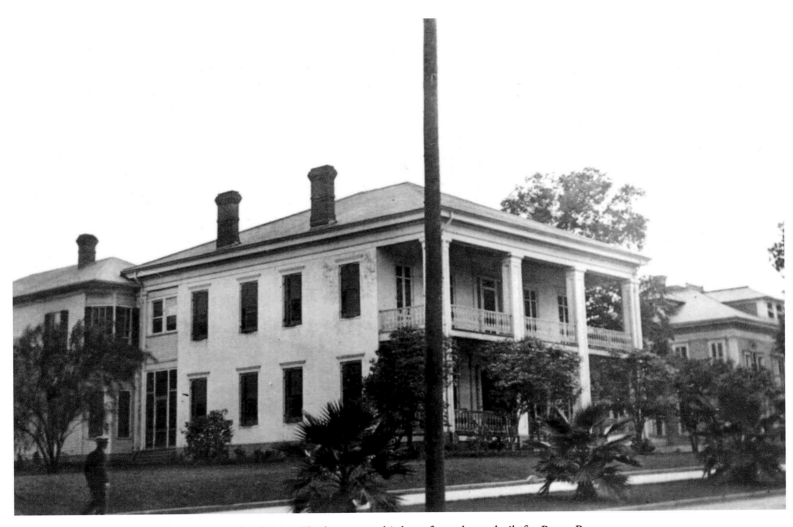

Located on North Boulevard between Royal and Saint Charles streets, this large frame house built for Baton Rouge businessman Nathan King Knox served as the official residence of Louisiana governors from 1887 until 1929, when it was razed on orders from Huey Long. In its place, Long ordered built a stucco Georgian mansion resembling the White House.

THE HUEY P. LONG LEGACY

(1930–1939)

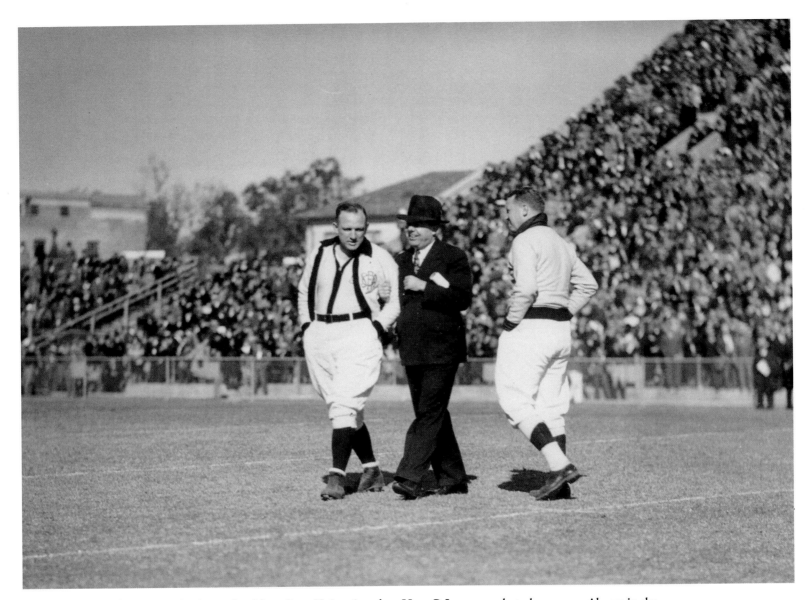

Football had long been an institution at Louisiana State University when Huey P. Long was elected governor. Always in the public eye, Long did not hesitate to confer with the referees during a game, even if it meant walking onto the field with them, as in this scene from around 1930.

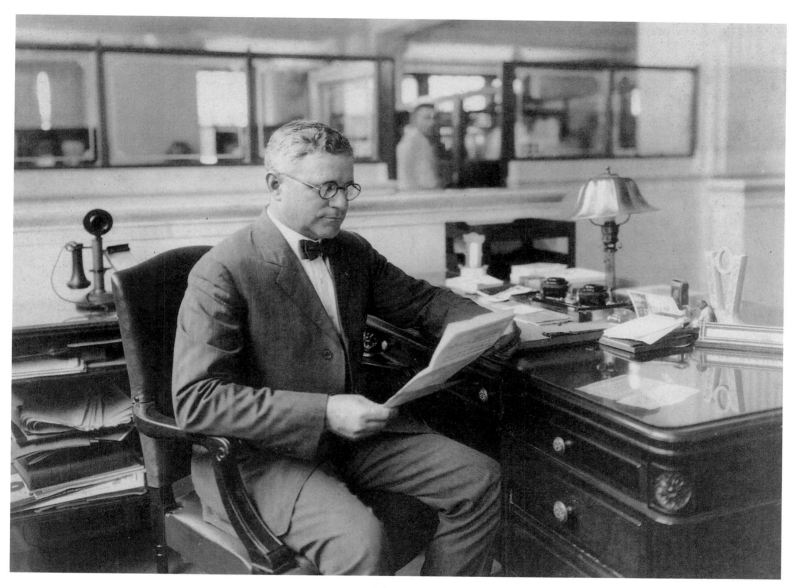

John B. Heroman, Sr., sits at his desk at the First National Bank, around 1930.

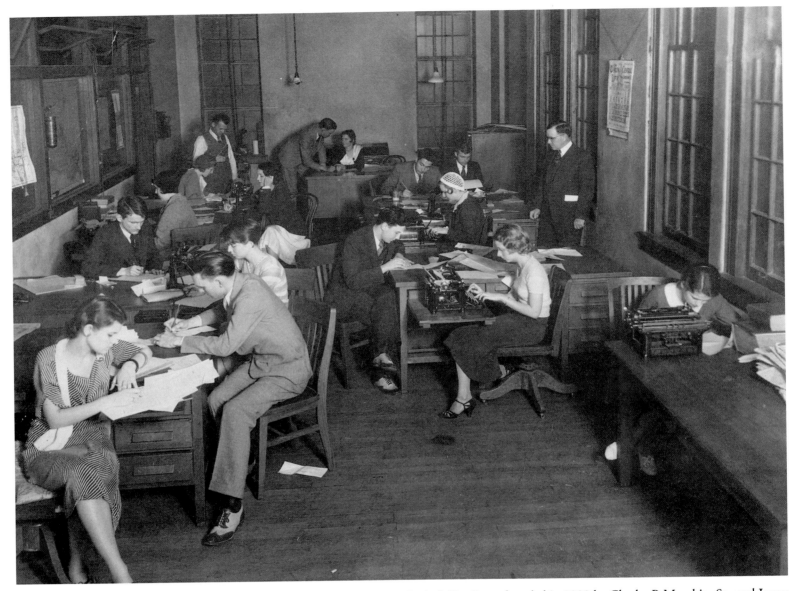

Baton Rouge has a long history with its newspapers. Capital City Press, founded in 1909 by Charles P. Manship, Sr., and James Edmonds, purchased the *State-Times*, an afternoon paper, that year. Capital City Press created the *Morning Advocate* in 1925 to provide the town's growing population with an early edition of the news. Here around 1930, staffers of the *Morning Advocate* work under somewhat crowded conditions in the newsroom downtown.

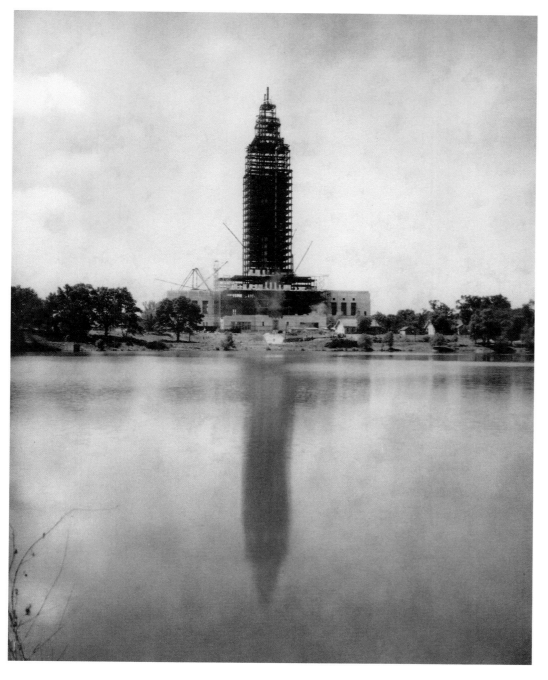

During his 1928 gubernatorial campaign, Huey P. Long advocated for construction of a new capitol to replace the old Louisiana State Capitol built in 1847. Ground-breaking for the new Capitol took place in 1930; construction ended 27 months later. The new Capitol—the tallest in the United States—cost $5 million to complete. Three years later, Huey P. Long would be assassinated in an interior hallway on his way out of the building.

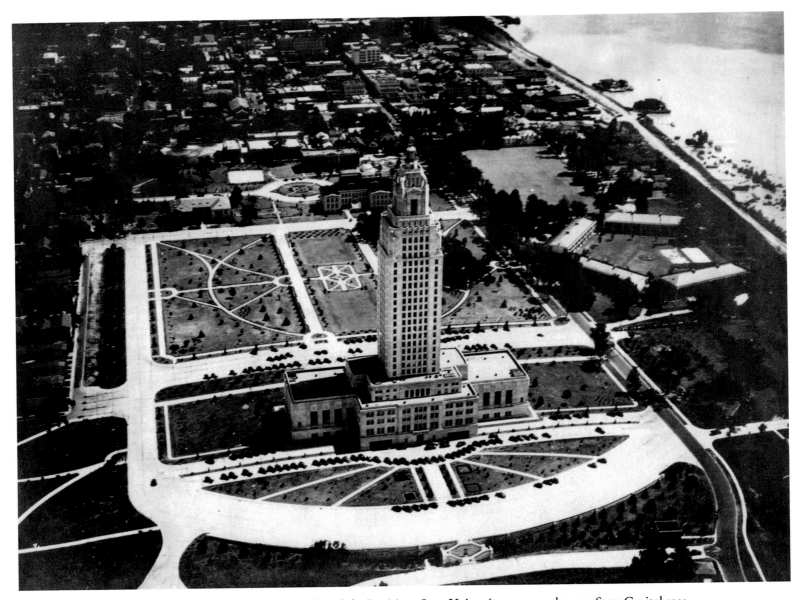

Sitting squarely on what had been the old Arsenal grounds and the Louisiana State University campus, the new State Capitol rose high above Baton Rouge. The Pentagon Barracks can be seen at right of the Capitol. At this point, around 1937, the Huey P. Long memorial had not yet been erected at his grave site in the formal garden on the south side of the Capitol.

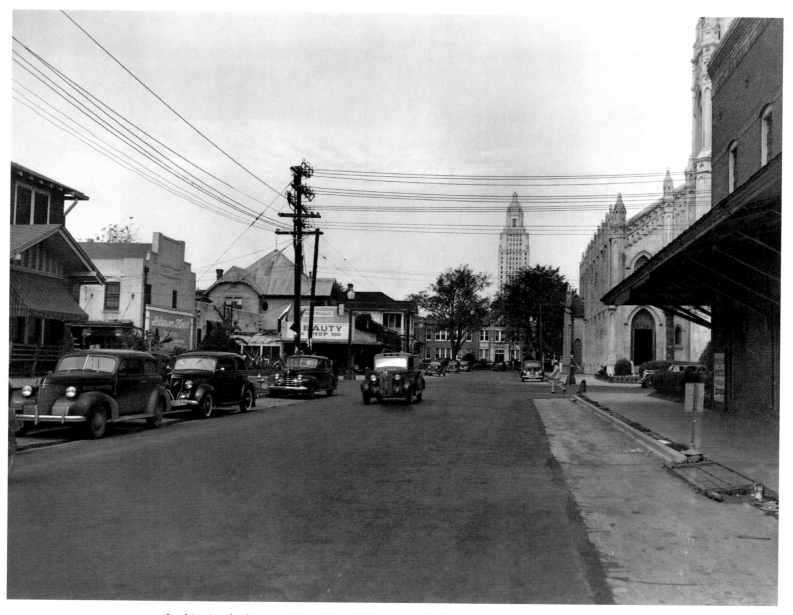

In this view looking north on Church Street toward the new State Capitol, around 1935, part of Saint Joseph Catholic Church can be seen at middle-right.

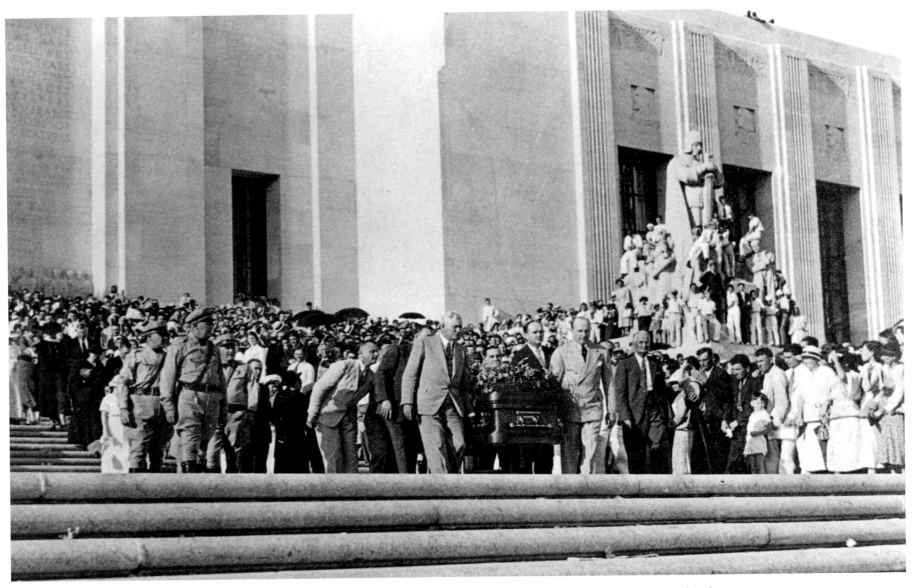

Following Huey P. Long's assassination, a public funeral was held on the grounds of the new State Capitol, September 12, 1935. After the public viewing of his body, Long's casket was carried to his grave site in front of the building.

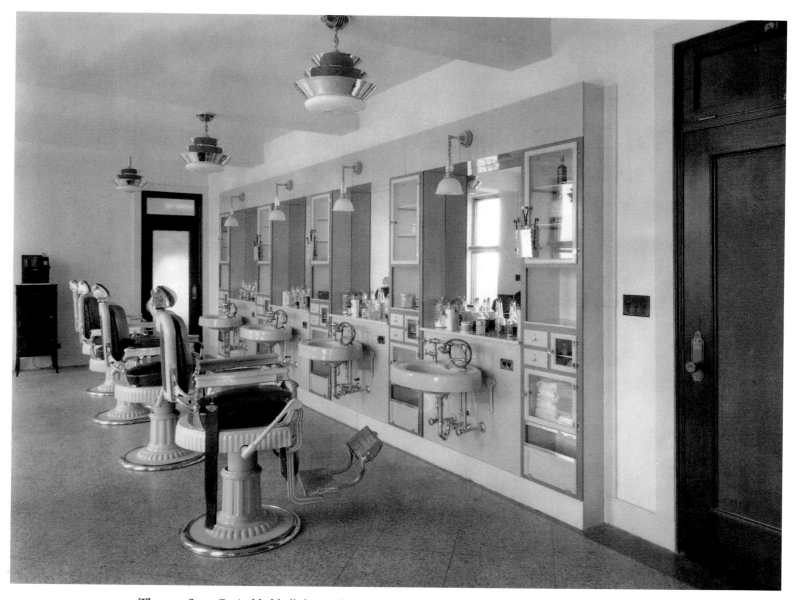

The new State Capitol held all the modern conveniences for state legislators, including this well-equipped barbershop on the seventh floor, seen here in 1932.

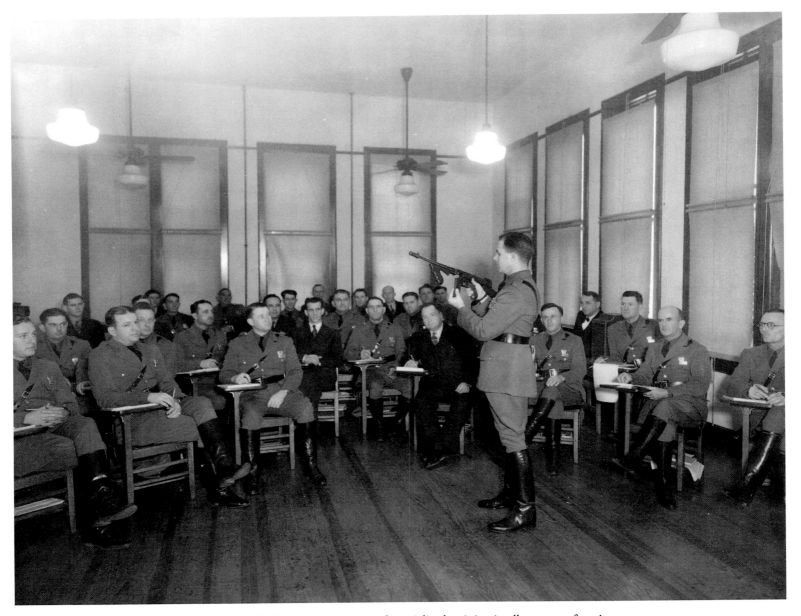

As the state police force modernized in the mid-1930s, troopers received specialized training in all manner of equipment, including this .45-caliber Thompson submachine gun, popularly called the "Tommy gun."

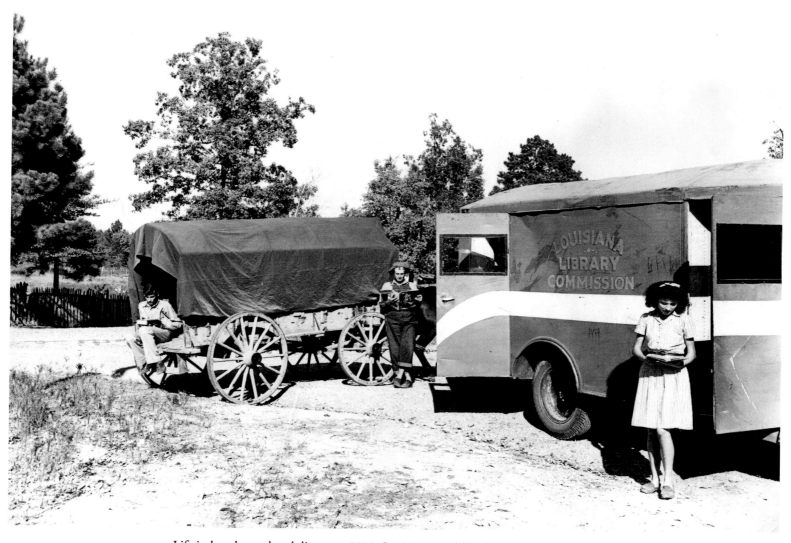

Life in largely rural and dirt-poor 1930s Louisiana could be harsh. The Louisiana Library Commission, established in 1920, partnered with the Carnegie corporation to establish a network of libraries throughout the state. Here around 1935, a rural family traveling in a covered wagon meets the Library Commission's bookmobile near Baton Rouge.

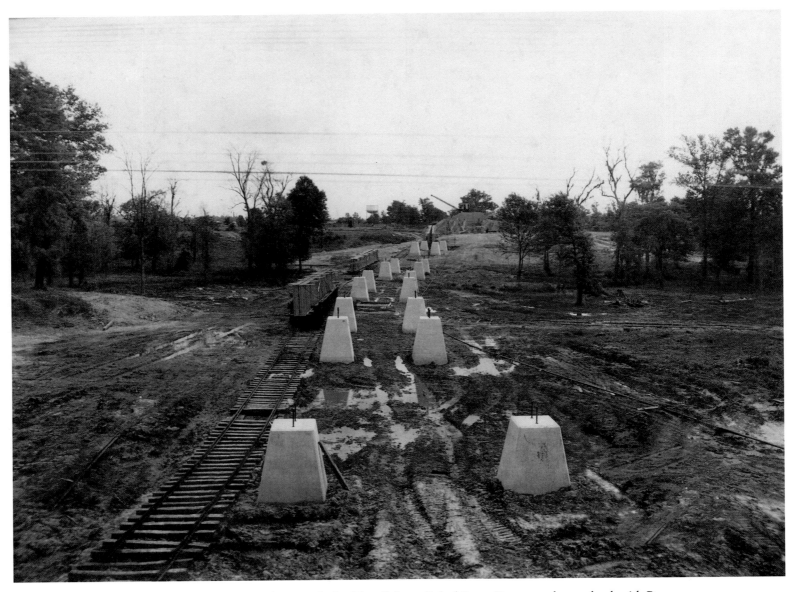

The second bridge across the Mississippi River to be named after Huey P. Long linked Baton Rouge on the east bank with Port Allen on the west bank. Though it was built largely as a railroad bridge, two narrow lanes for motor-vehicle traffic run along either side of its central railroad track. This image from April 11, 1938, shows the east-side approach under construction.

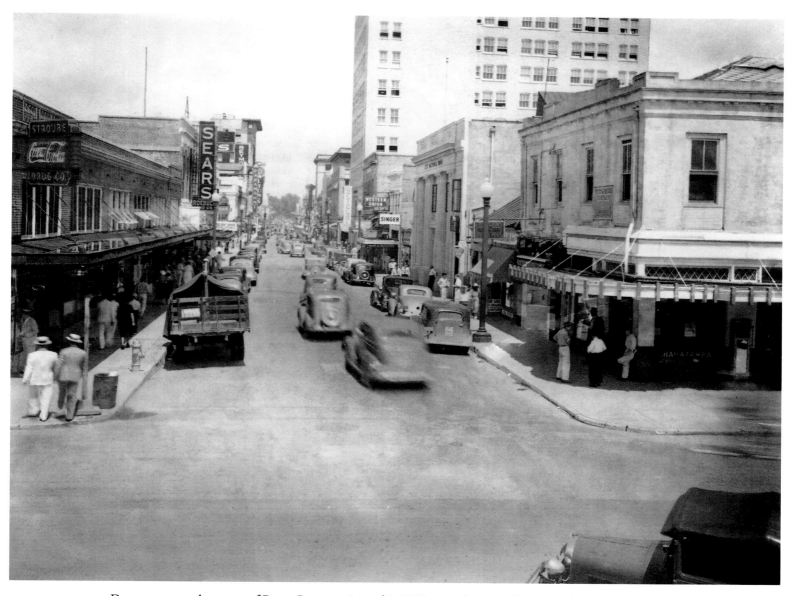

Downtown was the center of Baton Rouge activity; this 1935 scene shows its diversity of business. In the first block on the left are Stroube Drug Store, the Book Shop, Grand Beauty Parlor, the Rembrandt photography studio, and Sears, Roebuck. Businesses on the right include Orange Delight, National Jewelry & Optical Company, Coney Island Sandwich Shop, City National Bank, and the Western Union Telegraph Company, among others.

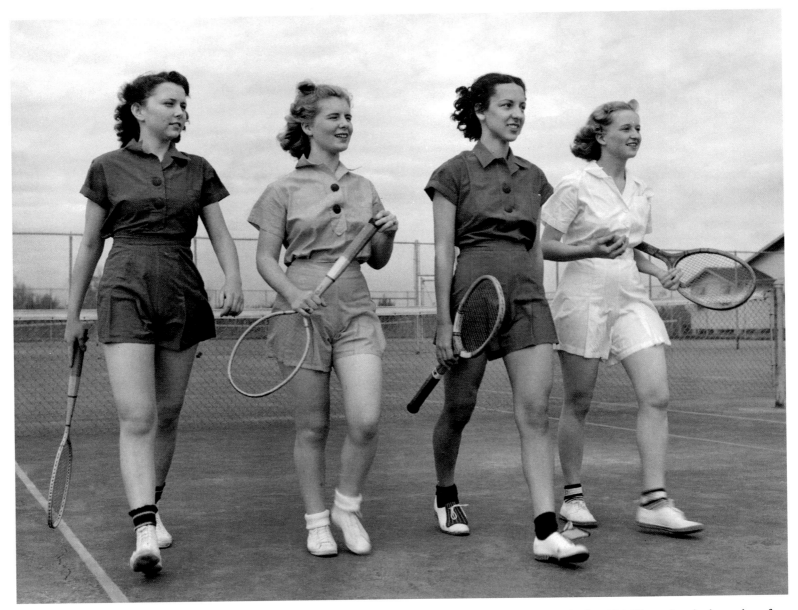

Olivia Davis became the first female student at Louisiana State University in 1904. Three decades later, these four young women are walking on the campus tennis court.

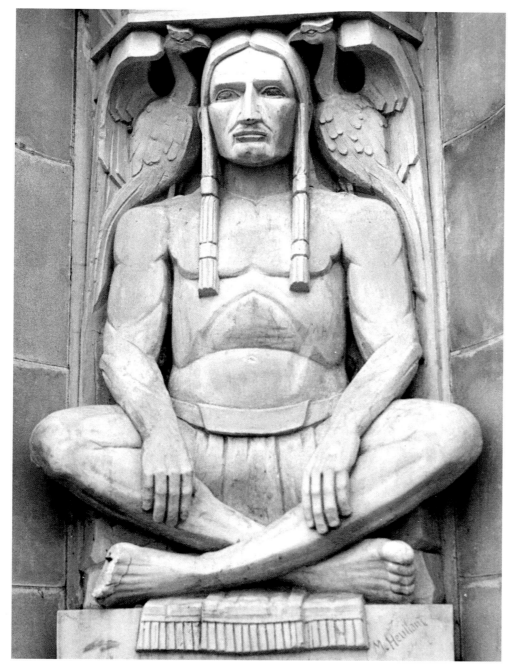

The State Capitol built under the Huey P. Long administration includes a number of Art Deco details. One detail, set into the stairs between two parking areas behind the building, is this fountain designed as an American Indian sitting in contemplation with a phoenix perched on either shoulder.

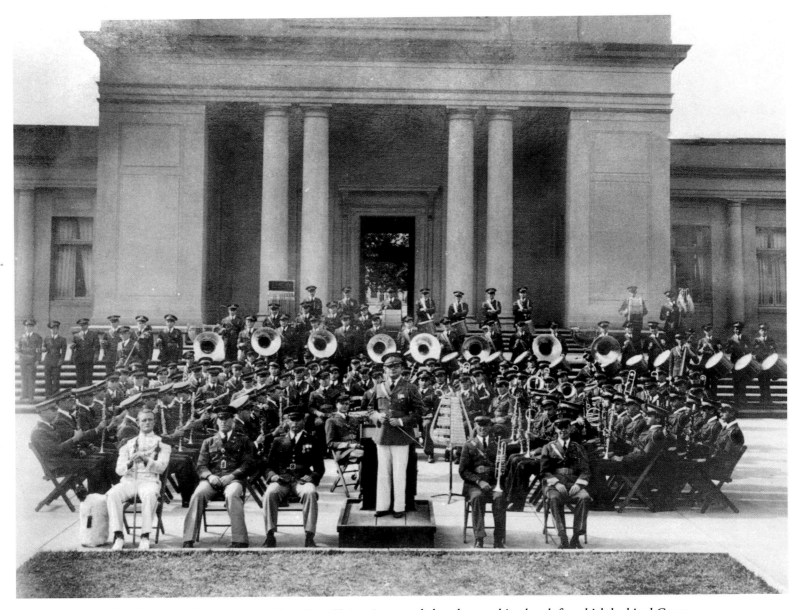

Governor Huey P. Long's personal interest in Louisiana State University extended to the marching band, for which he hired Castro Carazo, orchestra leader at the Roosevelt Hotel in New Orleans, and with whom he co-wrote a number of LSU songs. Here around 1940, the Tiger Band poses in front of Memorial Tower on the LSU campus.

The War Years and Beyond

(1940–1949)

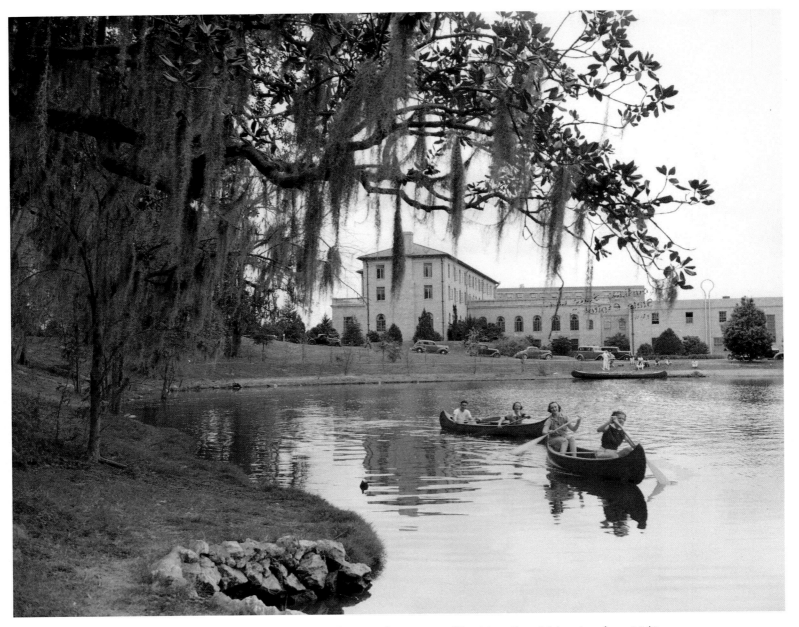

Students enjoy canoeing on the recently expanded City Park lakes near the campus of Louisiana State University, about 1940.

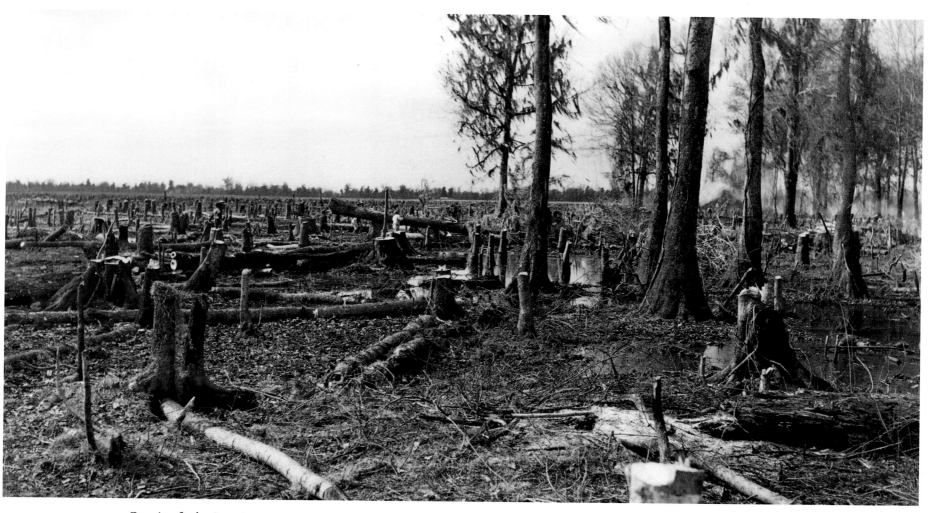

Opening for business in 1931, Baton Rouge's "downtown" Municipal Airport was located a few miles east of the river on the edge of town. In May 1940, the parish Police Jury took title to 1,000 acres of land approximately eight miles north of town and secured Work Projects Administration approval of plans for a new airport. The new facility, Harding Field, opened in February 1941. This image is from the initial stage of construction in 1940.

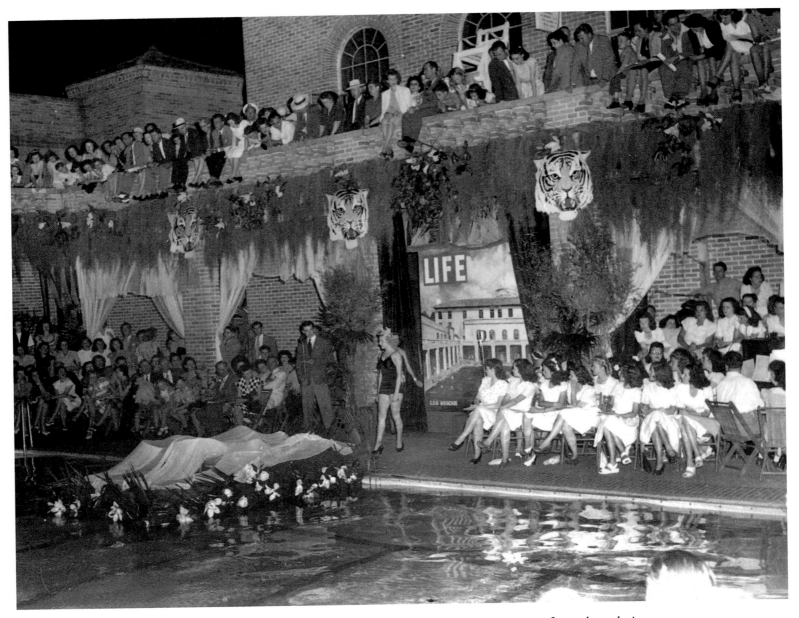

This Aquacade held at the LSU Natatorium around 1940 was one of many on-campus entertainments for students during homecoming. Here, a crowned beauty approaches the floating throne.

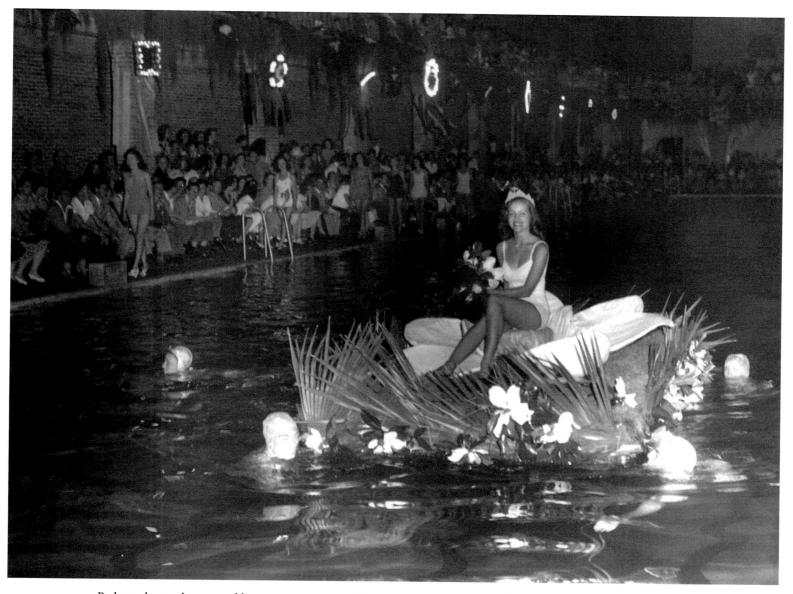

Perhaps the newly crowned homecoming queen, this young woman enjoys a quick spin around the pool on her floating throne. Her attendants provide the necessary motive power.

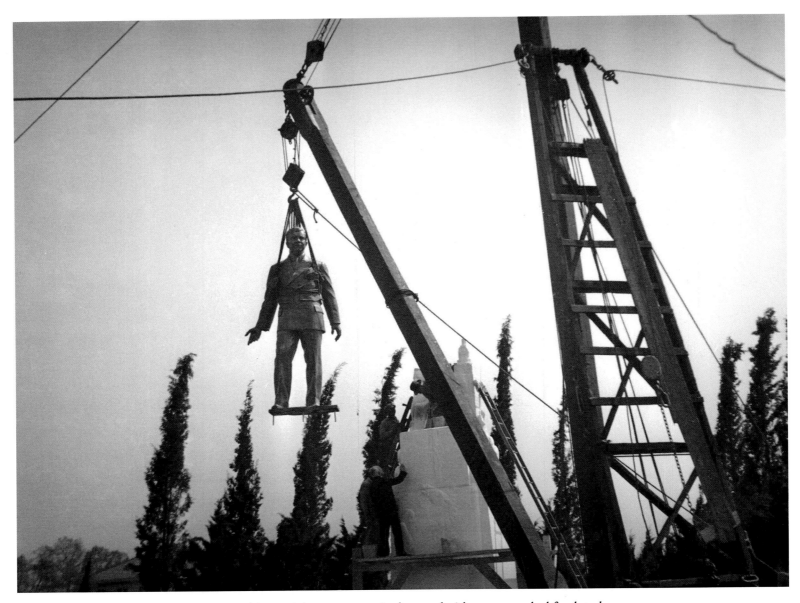

Five years after Huey P. Long's assassination, his remaining supporters in the state legislature earmarked funds to have this statue erected over his grave in front of the Capitol. In this view, workers stand ready beside the marble plinth, upon which the memorial still stands.

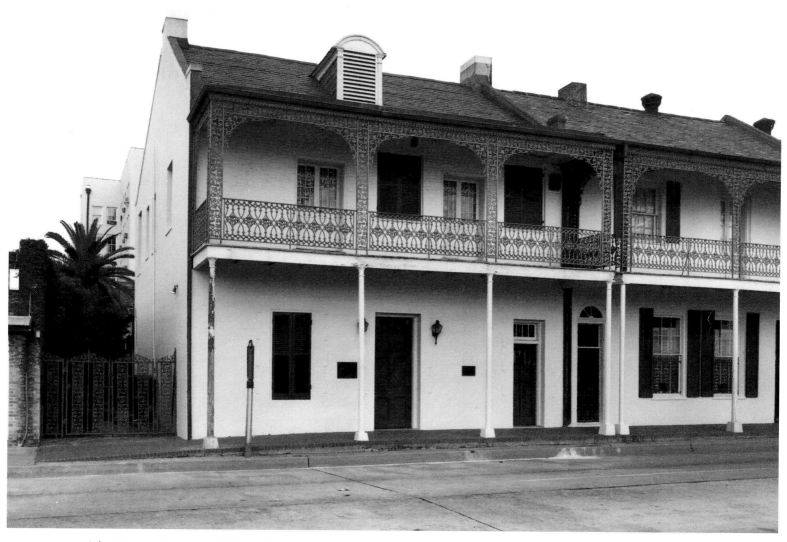

The Historic American Buildings Survey was begun in 1933 as a joint program of the American Institute of Architects, the Library of Congress, and the National Park Service. Its purpose was, and is, to document America's architectural heritage. This photo of the Tessier Building, constructed in 1800 on Lafayette Street in downtown Baton Rouge, was taken around 1940 as part of the survey.

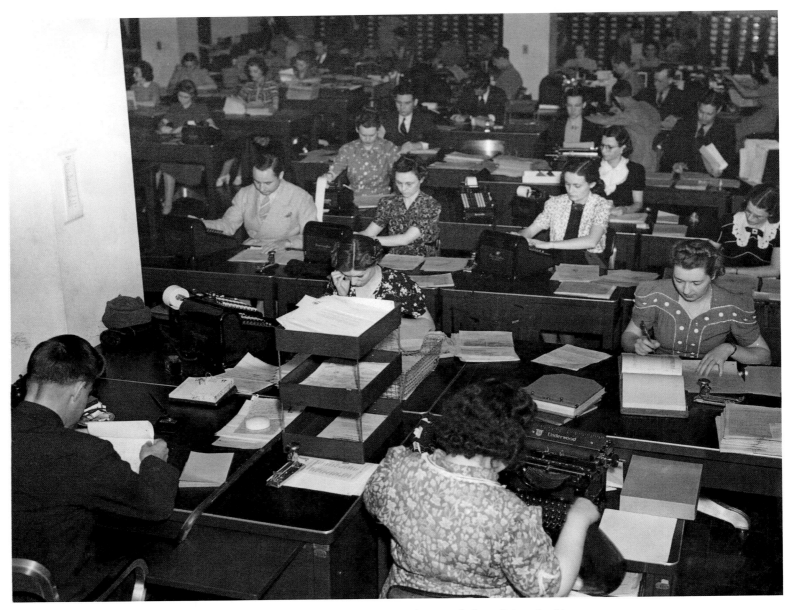

Employees of the Louisiana Department of Commerce and Industry work under crowded conditions in this photograph from around 1940.

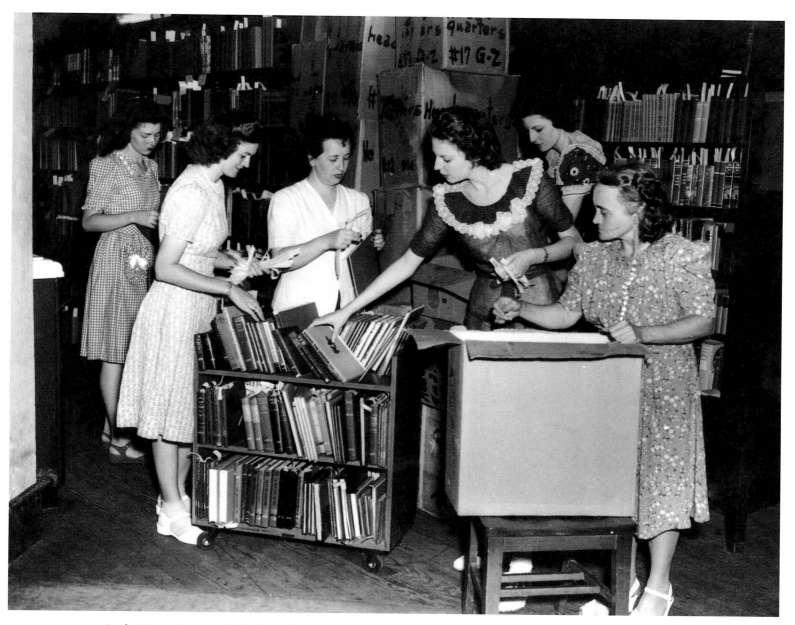

As the Depression eased, the State Library of Louisiana expanded its services. Here in the 1940s, a group of Extension Department employees pack up a shipment of books destined for the Saint Helena Parish Demonstration Library.

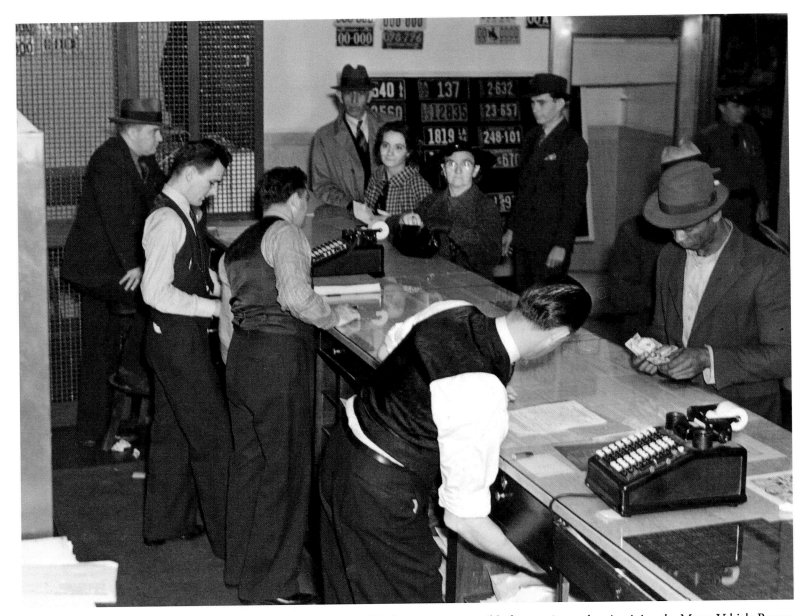

The Louisiana Department of Commerce and Industry was responsible for running and maintaining the Motor Vehicle Bureau in the 1940s. In this image from that period, bureau workers serve citizens in search of new licenses and motor vehicle tags.

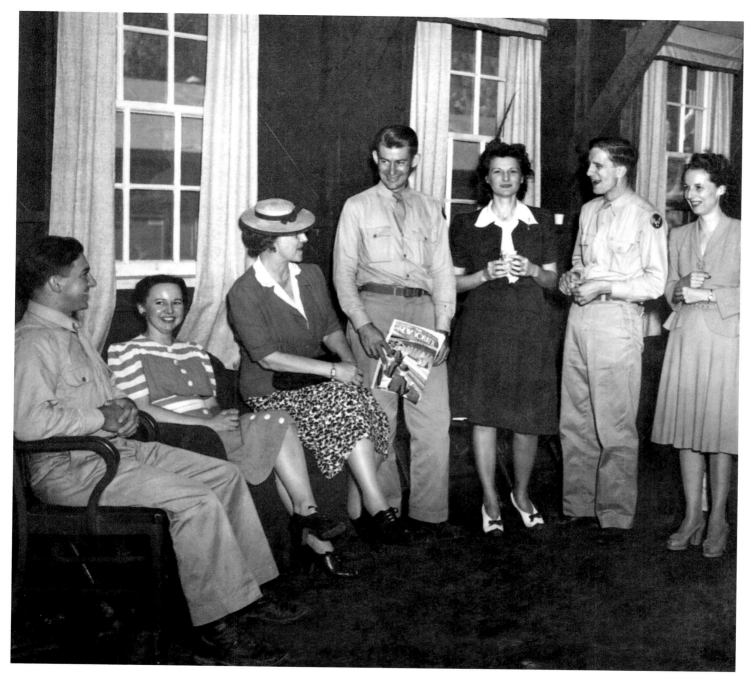

With the advent of World War II, Harding Air Field north of Baton Rouge became a training base that would house thousands of nascent airmen. When not flying, the Army Air Corps men could relax and enjoy the latest magazines, as well as the company of civilian women, at the base library.

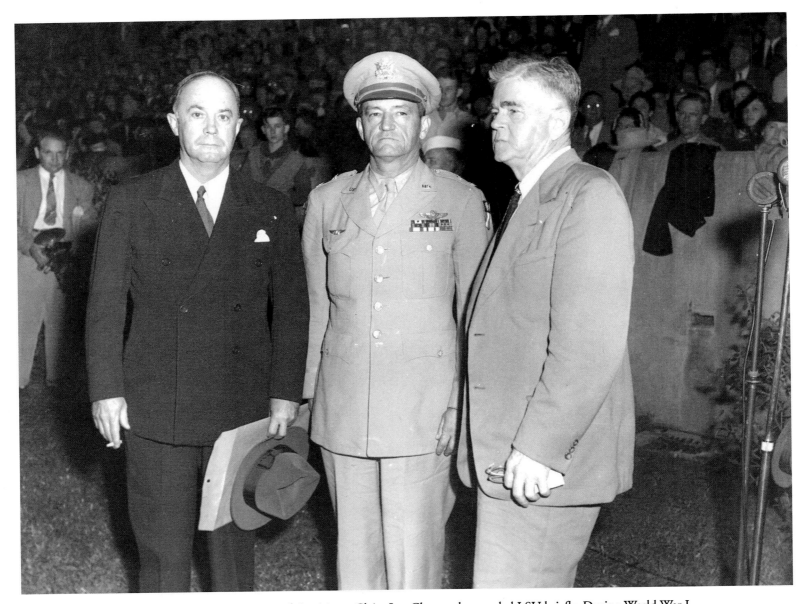

Born in Commerce, Texas, and raised in Waterproof, Louisiana, Claire Lee Chennault attended LSU briefly. During World War I he learned to fly while in the Army. After resigning from the Army in 1937, he volunteered with the Chinese, training airmen. In August 1941, Chennault established the Flying Tigers, a group of volunteer American airmen who fought the Japanese in Southeast Asia. Here around 1947, General Chennault, at center, visits with LSU president William B. Hatcher, at right.

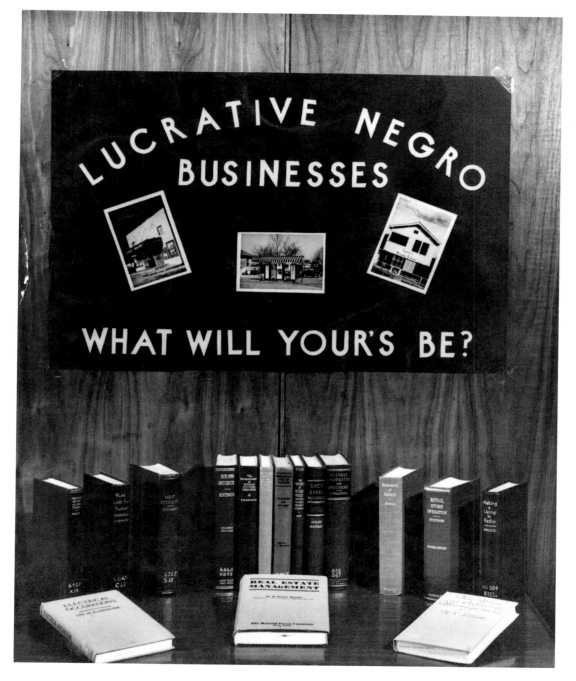

The State Library of Louisiana, working with Southern University and A&M College, put together a display for the Negro Services Department of the university in 1948. The library and the university worked together to aid the improvement of African-American businesses in Baton Rouge.

By the time of this February 1945 scene at the Humble Oil & Refining Company's refinery hospital, the city's many refineries were the source of aviation fuel, synthetic rubber, and a host of other products created for the war effort.

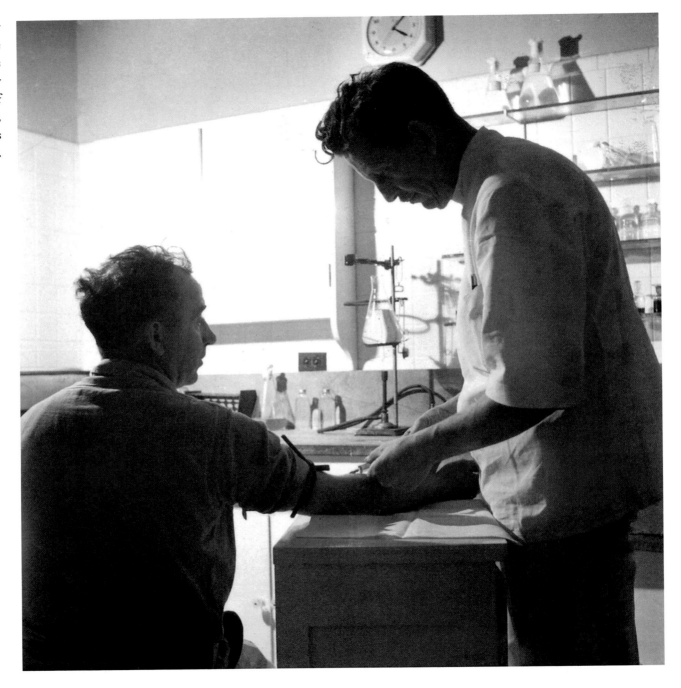

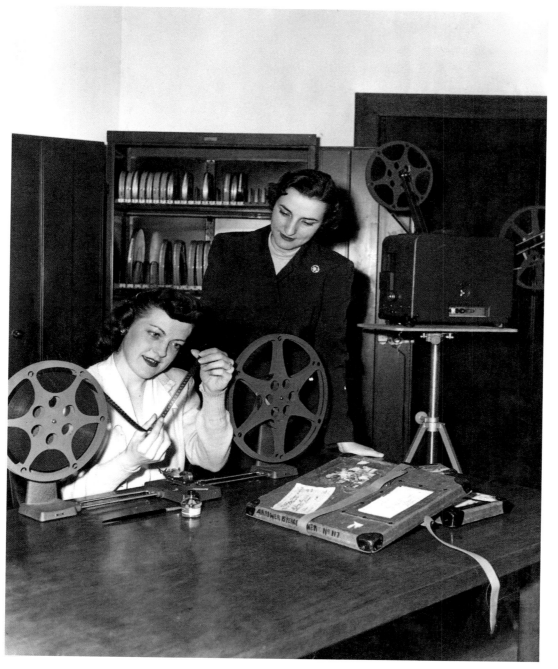

As new media technology is devised, public libraries provide these media to their patrons. In February 1950, Vivian Cazayoux and an assistant at the State Library of Louisiana inspect a reel of motion picture film before sending it out on loan.

Following a few decades' decline during which neither the Firemen's Parade nor the Mardi Gras Parade took place in Baton Rouge, Fat Tuesday made a comeback with the establishment of the Krewe of Romany in 1949. The return of the Mardi Gras Parade meant the return of downtown scenes such as this one from the 1950s.

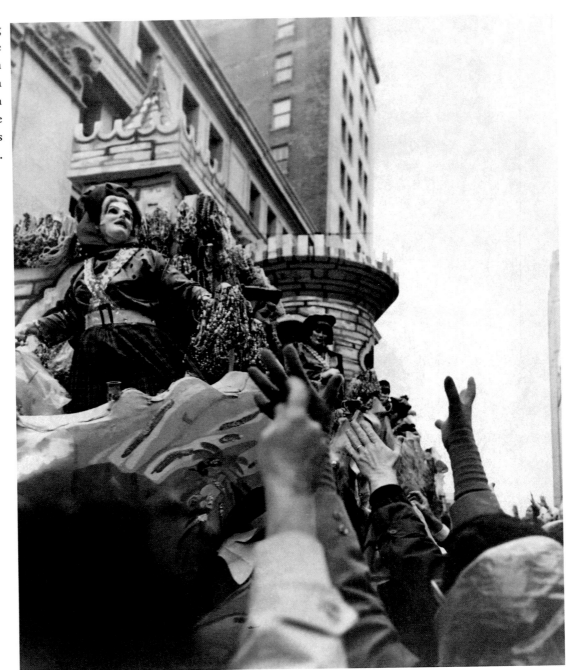

Postwar Baton Rouge

(1950–1960s)

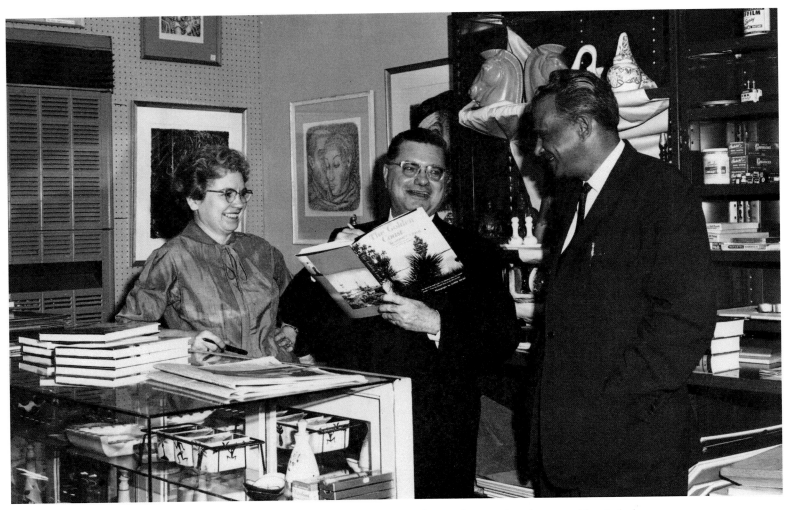

Before the days of corporate, big-box bookstores, Baton Rouge had a number of privately owned-and-operated book dealers. One such store, the Shortess Book Shop, kept the people of Baton Rouge in reading material. Here around 1955, Helen and Melvin Shortess speak with journalist and author Harnett T. Kane.

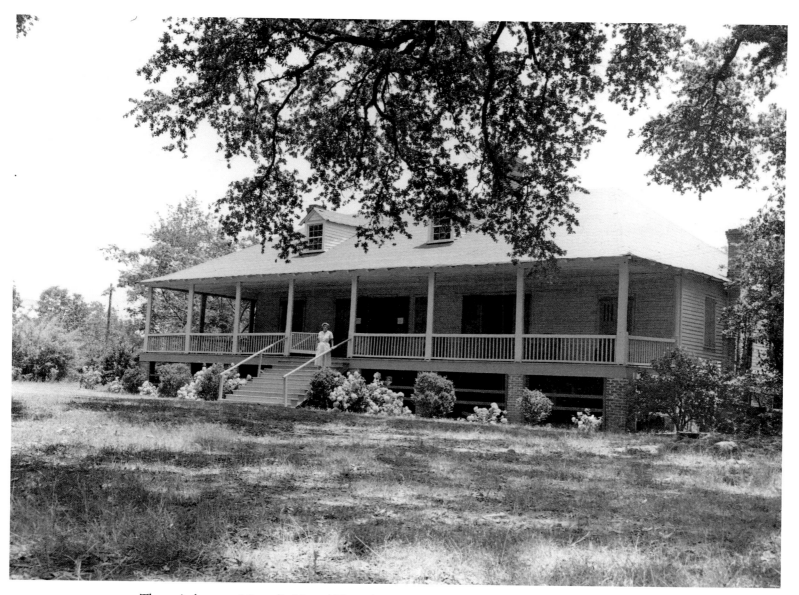

The main house at Magnolia Mound Plantation was constructed around 1791. Mrs. Blanche Duncan acquired the property after it had passed through numerous hands. In 1951, about the time of this photo, Mrs. Duncan hired a local architectural firm to create numerous alterations and additions to the house. In 1966 Magnolia Mound became a Baton Rouge Recreation Department property.

The State Library of Louisiana maintained a branch library, the Negro Services Department, at Southern University and A&M College. In this scene from the early 1950s, Mrs. Murray, seated, and an assistant work with library materials.

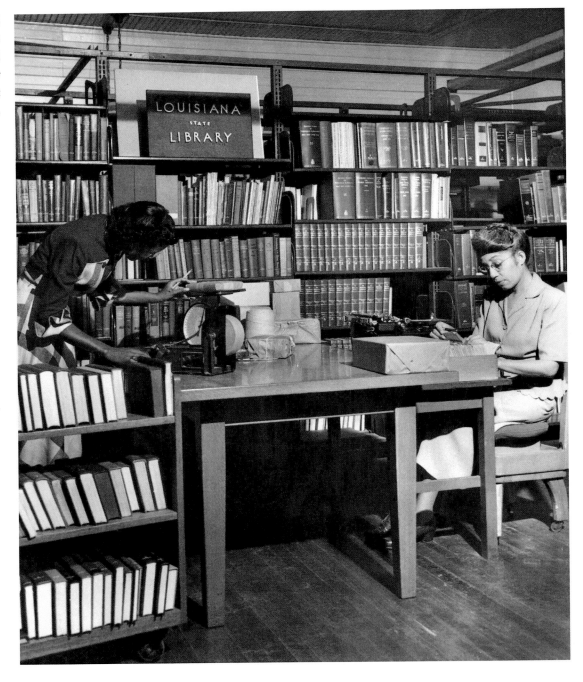

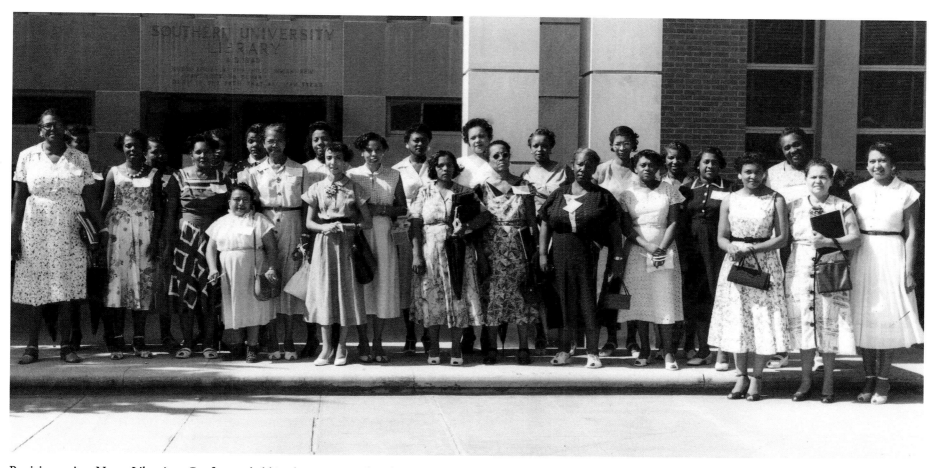

Participants in a Negro Librarians Conference held in the 1950s stand in front of the Southern University Library. Attendees arrived in Baton Rouge from all over the state.

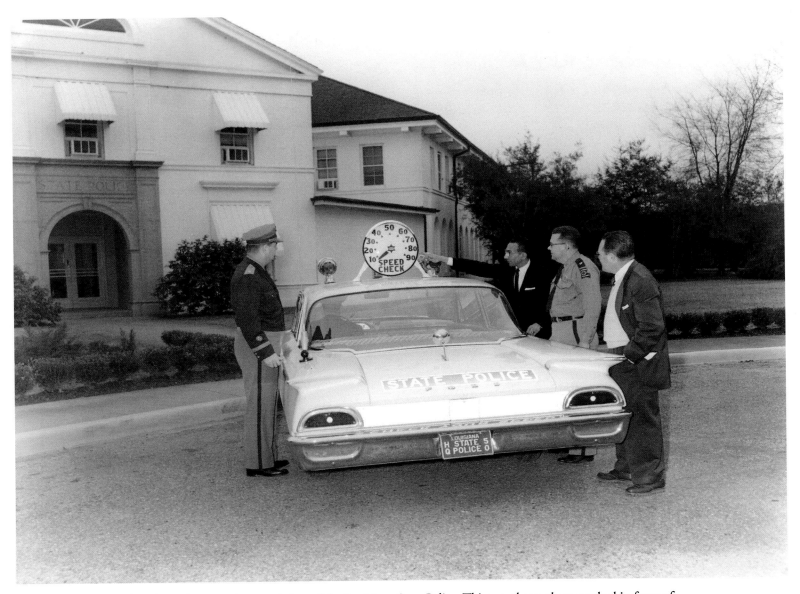

Enforcing traffic laws has always been a primary mission of the Louisiana State Police. This patrol car, photographed in front of the State Police Headquarters in Baton Rouge around 1960, has the latest in speed-checking devices installed on its roof.

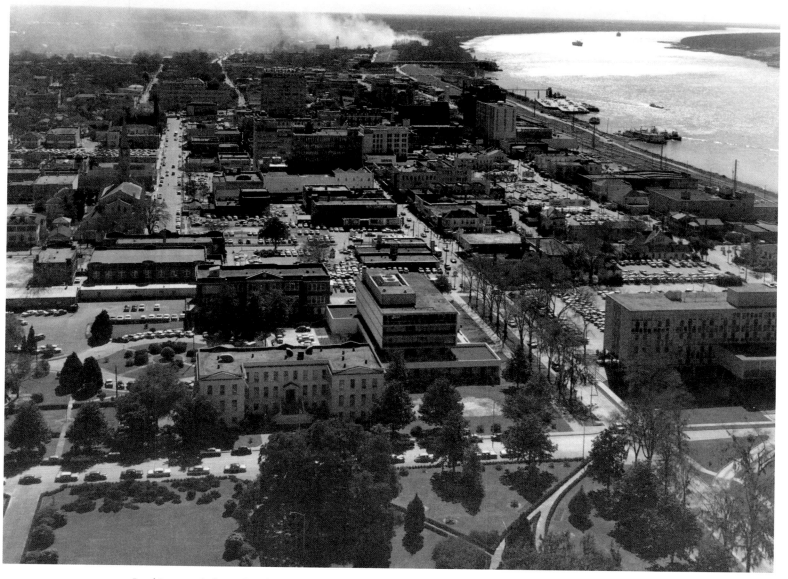

Looking south from the observation deck of the new State Capitol in 1960, this bird's-eye view of Baton Rouge shows many buildings in the foreground that have been demolished over time to make room for newer state buildings.

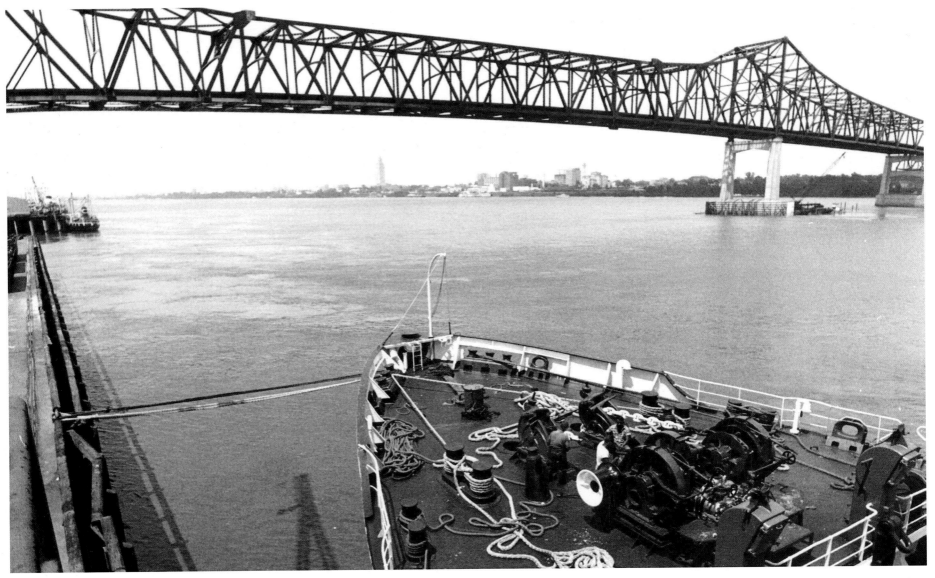

A new bridge crossing the Mississippi River was built in the 1960s. Construction, completed in 1968, was still under way when this shot of the span, as yet without its roadbed, was recorded.

The new Capitol, erected on the site of the old military base that LSU occupied from the 1870s through the 1920s, maintained a few of the old structures. Among them were the Pentagon Barracks, now used for state offices, legislators' apartments, and a tourist center. In this scene from 1969, state workers erect a Christmas tree in the Barracks courtyard.

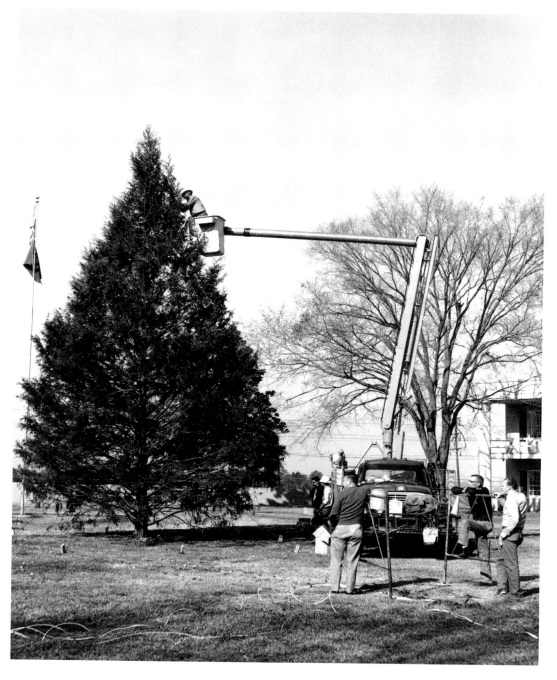

This aerial view of Baton Rouge, created around 1960, faces east from the observation deck of the new State Capitol. The old Arsenal building can be seen at center, just past the formal garden. Behind the Arsenal, a recently built roadway connects to Interstate 110, part of which is visible in the upper-right corner.

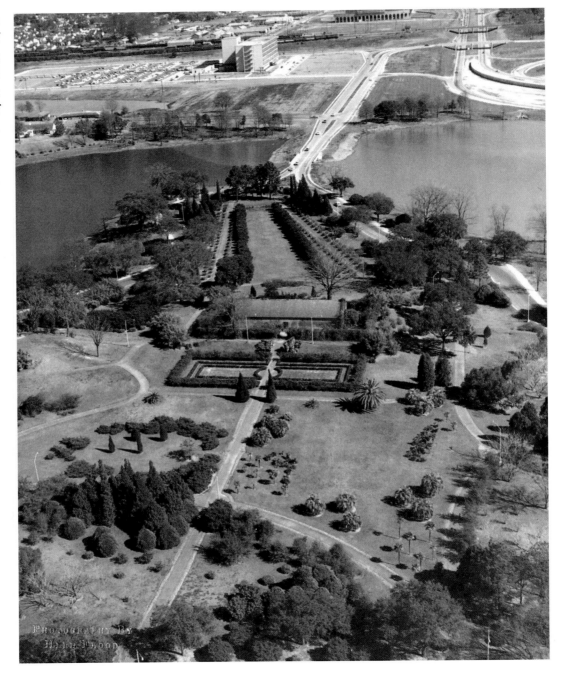

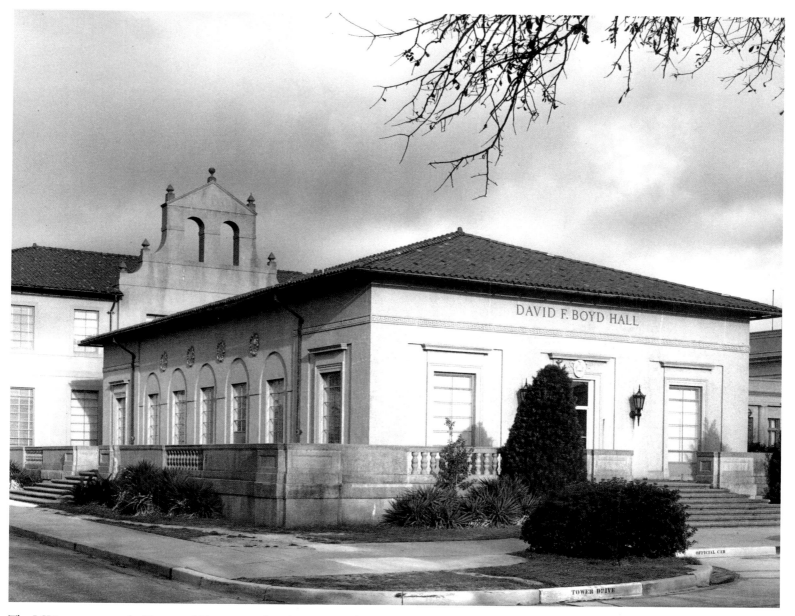

The LSU campus, nearly 40 years old here around 1965, continued to grow through the years. The David F. Boyd Hall was constructed to serve as administrative offices.

The Campanile and Memorial Tower anchored the eastern arm of the central LSU campus when the university grounds were first laid out. This scene from around 1965 provides an excellent view of the structure.

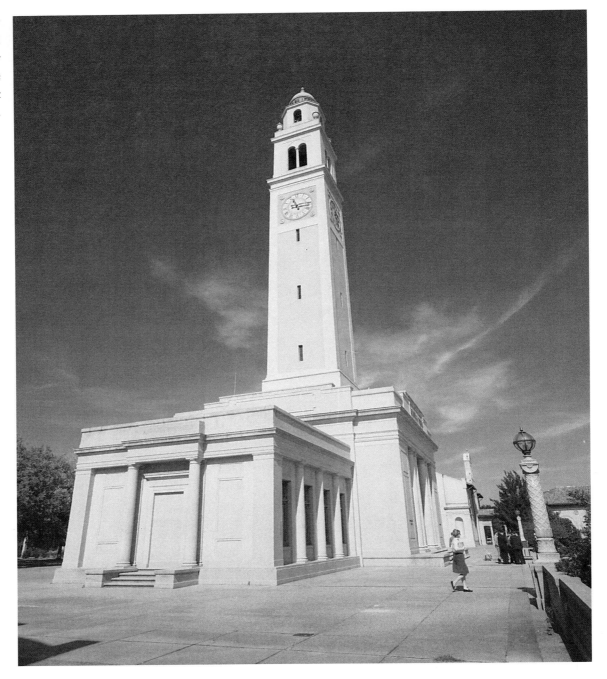

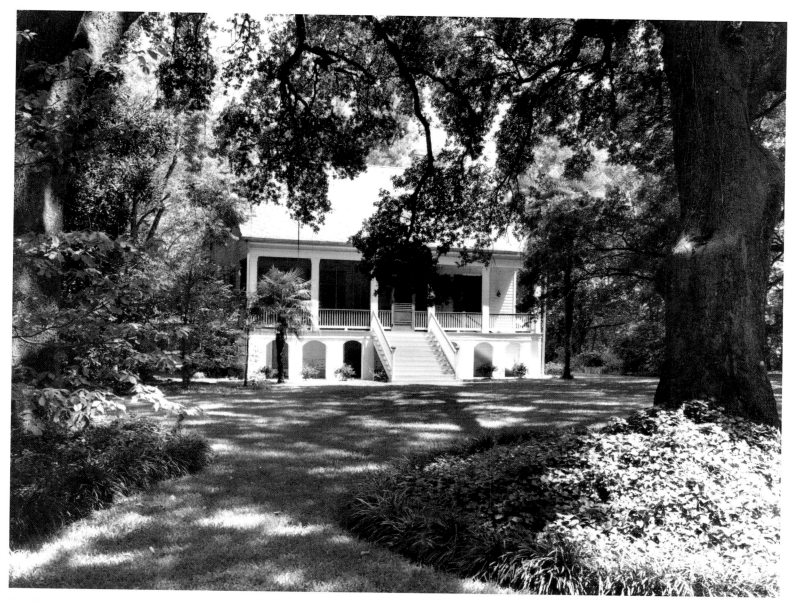

Seen here around 1965 is the southwest facade of the Santa Maria Plantation house, built in 1877. Located on Perkins Road south of town, the home is listed on the National Register of Historic Places.

Notes on the Photographs

These notes, listed by page number, attempt to include all aspects known of the photographs. Each of the photographs is identified by the page number, a title or description, photographer and collection, archive, and call or box number when applicable. Although every attempt was made to collect all data, in some cases complete data may have been unavailable due to the age and condition of some of the photographs and records.